# MAGRITTE

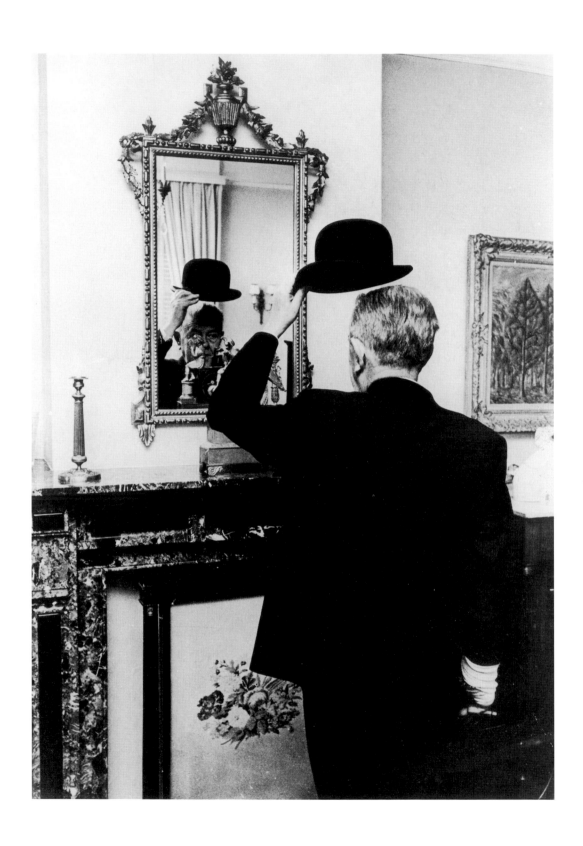

# MAGRITTE

*Siegfried Gohr*

SAN FRANCISCO MUSEUM OF MODERN ART • DISTRIBUTED BY HARRY N. ABRAMS, INC.

This catalogue is published on the occasion of the exhibition *Magritte*, organized by the Louisiana Museum of Modern Art, Humlebaek, Denmark, in cooperation with the San Francisco Museum of Modern Art. The San Francisco presentation, on view from May 5 to September 5, 2000, was organized by Gary Garrels and Janet Bishop.

Portions of this book first appeared in *Louisiana Revy 39*, no. 3 (August 1999), in conjunction with the Louisiana presentation of the exhibition.

Major support for the San Francisco presentation of *Magritte* has been provided by Judy and John Webb.

Library of Congress Cataloging-in-Publication Data:

Magritte, René, 1898–1967.
    Magritte / essay by Siegfried Gohr.
        p. cm.
    ISBN 0-8109-6700-6
        1. Magritte, René, 1898–1967—Exhibitions. 2. Surrealism—Belgium—Exhibitions.
    3. Magritte, René, 1898–1967—Influence—Exhibitions. 4. Painting, Modern—20th century—
    Exhibitions. I. Gohr, Siegfried. II. San Francisco Museum of Modern Art. III. Title.

    ND673.M35 A4 2000
    759.9493—DC21

                        99-059835

Publication Director: Kara Kirk
Publication Coordinator: Alexandra Chappell
Designer: Terril Neely

COVER
*L'Empire des lumières* (The Dominion of Light), 1961 (detail of pl. 59)

FRONTISPIECE
René Magritte, n.d. (photographer unknown)

Production by Tijdsbeeld, Ghent.
Printed and bound in Belgium by Die Keure, Bruges.

Distributed by Harry N. Abrams, Inc.
100 Fifth Avenue
New York, NY 10011
www.abramsbooks.com

## LENDERS TO THE EXHIBITION

Pierre and Mickey Alechinsky

Arakawa and Madeline Gins

Art Gallery of Ontario, Toronto

Banque Artesia Belgique, Brussels

Madame Maria Do-Céu Cupertino de Miranda

Elkon Gallery, New York

Fortis Bank, Brussels

Galerie Brüsberg, Berlin

Galerie Vedovi, Brussels

Hamburger Kunsthalle, Hamburg

Hirshhorn Museum and Sculpture Garden, Smithsonian Institution

Louise and Bernard Lamarre

Los Angeles County Museum of Art

Mayor Gallery

Lois and Georges de Menil

The Menil Collection, Houston

Musée de Grenoble, France

Musée d'Ixelles, Brussels

Museum of Contemporary Art, Chicago

Museum moderner Kunst, Stiftung Ludwig, Vienna

National Gallery of Art, Washington, D.C.

Mr. Roger Nellens

Philadelphia Museum of Art

The Robert Rauschenberg Foundation

Leslee and David Rogath

San Francisco Museum of Modern Art

Scottish National Gallery of Modern Art, Edinburgh

Sprengel Museum, Hannover

Tate Gallery, London

Private collections

# DIRECTOR'S FOREWORD

*David A. Ross*

It is an extraordinary occasion for the San Francisco Museum of Modern Art to present a survey of René Magritte's work—the first one on the West Coast in over thirty years. Many visitors to the exhibition will recognize Magritte's signature work *La Trahison des images* (The Treachery of Images), where the artist depicts a pipe above the caption "Ceci n'est pas une pipe" (This is not a pipe), which has been generously lent by the Los Angeles County Museum of Art. We are proud and delighted that this exhibition offers yet another true highlight of Magritte's work: *Les Valeurs personnelles* (Personal Values). This exceptional painting, which was acquired by SFMOMA in 1998 through the unparalleled generosity of Museum Trustee Phyllis Wattis, will no doubt intrigue SFMOMA visitors for generations to come.

The exhibition is built on a core of a show presented in 1999 at the Louisiana Museum of Modern Art in Humlebaek, Denmark, which examined the artist as a forerunner and source of inspiration for Pop and Conceptual art. The SFMOMA presentation also emphasizes major themes that occur in Magritte's œuvre—from the fracturing of perception and voyeurism to physical displacement and metamorphosis.

The original exhibition was beautifully assembled by Louisiana Museum director Steingrim Laursen, with the assistance of Katrine Mølstrøm, curatorial assistant. Without the support and encouragement of Mr. Laursen, the exhibition in San Francisco would not have been possible. We are equally indebted to Charly Herscovici, Succession René Magritte, for his enthusiastic and tireless assistance in securing loans and

facilitating the publication of this volume. Further thanks are due to my colleagues Richard Calvocoressi, director, and Patrick Elliot, vice director, at the Scottish National Gallery of Modern Art, Edinburgh, where the show was presented in the winter of 1999–2000.

We are grateful to the lenders from the Louisiana exhibition who generously agreed to make their beloved works available for the enjoyment of San Francisco visitors. A number of additional lenders stepped forward to make the presentation at SFMOMA as rich and engaging as possible. These generous individuals and institutions are acknowledged on page six of this volume.

A great number of SFMOMA staff members contributed their time and expertise to this undertaking. In particular, I would like to acknowledge the contributions of Gary Garrels, former Elise S. Haas chief curator and curator of painting and sculpture; Janet Bishop, Andrew W. Mellon Foundation associate curator of painting and sculpture; Adrienne Gagnon, curatorial associate; Lori Fogarty; senior deputy director; Jennifer O'Neal, administrative assistant in the Department of Painting and Sculpture; Sarah Tappen, assistant registrar; and Emily Hage, acting curatorial associate. We are equally indebted to Kara Kirk, publications and graphic design director; Alexandra Chappell, publications coordinator; and Terril Neely, senior graphic designer, whose editorial acumen and design expertise are reflected on these pages. Thanks also go to Siegfried Gohr for his thoughtful essay, and John William Gabriel, who translated it into English.

And finally, my sincere thanks to Judy and John Webb, without whom it would not have been possible to present the work of this extraordinary artist.

# THE VISIBLE SECRET OF RENE MAGRITTE

*Siegfried Gohr*

Let us put ourselves for a moment in the shoes of someone strolling through a major museum of twentieth century art. He will find that the works are arranged according to the styles and categories that have been canonized by the history of art since the last world war. He enjoys the Fauves, especially Henri Matisse; he admires the work of the Expressionists; then he may enter into the unsettling world of Cubism, an art from which Pablo Picasso and Georges Braque eliminated color and the familiar crutch of perspectival depth shortly before the First World War. The shadow of that war fell in turn on the German Expressionists and the Italian Futurists, infusing their view of the world with anxiety and drama. Not only did objects begin to disintegrate, as they had already done with Picasso, but the ground itself began to quake under the feet of Max Beckmann, Umberto Boccioni, and Kurt Schwitters. During the war the Dadaists began their despairing game, in which irony was shot through with nostalgia.

After the war the idioms of modern art multiplied, and the visitor to our imaginary museum soon senses the harsher, more rigorous dialects of the interwar period, as voiced by Fernand Léger, Georges Rouault, Hans Arp, and Piet Mondrian. But then, in 1925, a Babel-like confusion of tongues, triggered by the Surrealists, encroached upon the attempts to create a new order in art, "l'art pur" of artists such as Mondrian. Old themes, old styles, and also content of a literally deranged kind, raised their ugly heads in the midst of modernity. Here the revolt no longer took the form of a way of seeing reality but that of a rebellion against reality itself and the signs and symbols derived from it.

When our *flâneur* walks into the rooms of the museum devoted to works made around 1930, he may be in store for a strange and unsettling experience. Glancing at examples of Surrealist art, he is likely to feel a visual jolt that exerts an irresistible attraction. It will come from an apparently realistic picture, painted in a traditional, imitative style, which nevertheless exudes a certain coolness. And what is most important: in this painting, which pretends to mirror an ordinary, even banal thing, something is wrong. "Ceci n'est pas une pipe" (This is not a pipe) is written in old-fashioned school longhand under a rendering of what looks to be a perfectly shaped pipe (pl. 21). Our museum visitor is filled with a sense of intrigue, what I should like to call the Magritte effect. For none of the other Surrealist painters produce a shock of precisely this kind. Naturally, there are the bizarre landscapes of Yves Tanguy, the complex, erotically evocative scenes of Salvador Dalí, the suggestive play with material textures in the work of Max Ernst, the ironically mythical cosmos of Hans Arp.

But the Magritte effect works differently. In front of the pictures of the other artists, the viewer is aware of their efforts to expand the range of visual imagery by plumbing the unconscious mind, their attempt to explore uncharted territory in both the perceptible and the imagined worlds. But with Magritte, time-tested mimesis, the imitation of reality, seems to remain intact—until the baffling or unsettling effect of his works takes hold and we realize that the artist presents us with a riddle or paradox that he has no intention of unraveling.

If we approach the painting more closely, we can see that its special interest does not arise from any particular virtuosity of paint handling or realism; indeed on closer scrutiny the treatment appears almost wooden, oddly dull and flat. There is no comparison with the masterly handling of Dalí or with the restlessness and curiosity of Ernst, who forced his paint into bizarrely graceful shapes by introducing such technical innovations as frottage and the dripping of paint.

No, Magritte does not dazzle, like some fifteenth-century Flemish master reborn. Though the painterly and aesthetic issue he addresses remains reality, it is a modern reality that harbors ambiguities of an entirely different kind to that of the late-medieval, symbolic realism of the masters of Bruges, Ghent, or Brussels. What, then, is the Magritte effect?

## ORIGINS

When one travels by train to Paris from the east, from Cologne, say, one passes through Belgium, which starts a few miles after Aachen. Once one has left the wooded Ardennes, the countryside outside the compartment window begins to be dotted by dark, dust-coated industrial plants, most of them ranged along the Maas and Sambre rivers. Until recently the impression, especially around Charleroi, was dominated by the ghostly, oppressive atmosphere of abandoned industrial ruins. It was a grey, smoky region, where coal and steel plants loomed over the tortured landscape along the slow, brackish Sambre. How much more desolate this "black land" of Belgium must have looked when René Magritte

was born in 1898, in Lessines. David Sylvester was right to begin his comprehensive monograph on the artist with a chapter entitled "In a Grey Country."[1] Explaining Magritte's often grey palette in terms of his background is tempting, since grey, as a color and as a mood, seems to reflect the region his family came from.

The temptation to biographical reference is greater still when one considers some of the earliest events in Magritte's life. His mother's suicide in 1912 was a horrific experience, though it also had the effect of attracting attention for "the son of the suicide," as he was known to the people of Châtelet, the small town where the family lived at the time. Régina Magritte had been unhappy there and had made several attempts to take her own life before, on a February night in 1912, she disappeared from home, where her husband had kept her under lock and key. It was seventeen days before her body was found, a mile away, in the Sambre river. She had drowned herself.

Magritte once recounted the circumstances of his mother's death to his friend, Louis Scutenaire, who told the story in his book on Magritte:

> *Still a young woman, his mother committed suicide when he was twelve* [sic] *years old.*
>
> *She shared a room with her youngest child, who, finding himself alone in the middle of the night, woke up the rest of the family. They searched in vain all over the house; then, noticing footprints on the doorstep and on the pavement, followed them as far as the bridge over the Sambre, the local river.*
>
> *The painter's mother had thrown herself into the water, and when the body was recovered her face was found to be covered by her nightdress. It was never known whether she had hidden her eyes with it in order not to see the death which she had chosen, or whether the swirling currents had veiled her thus.*
>
> *The only feeling Magritte remembers—or imagines he remembers—in connection with this event is one of intense pride at the thought of being the pitiable centre of attention in a drama.*[2]

There are a number of paintings in which the artist, who otherwise remained silent about these events, reflected on the death of his mother.

Around this time Magritte made his first paintings and took drawing lessons. In 1913 he enrolled in the high school at Charleroi, but left in 1916 to attend the Académie des Beaux-Arts in Brussels. During the First World War this school formed an important gathering place for the city's writers, artists, musicians, and intellectuals, since many other cultural institutions had closed on account of the hostilities.

This chance grouping of young minds may be considered the germ from which the Belgian Surrealist movement would grow after the war. Without listing the many participants, journals, and activities of this avant-garde, suffice it to say that for Magritte the situation proved crucial. Moreover, he participated in the rapidly developing movement in innovative Belgian art not only as a painter but also as an essayist and poet. It

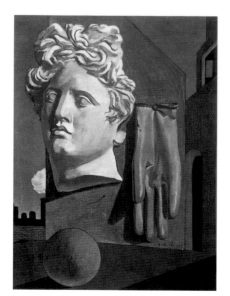

could even be said that he played a significant role in the new advances, though the tone was set largely by writers such as E. L. T. Mesens and Paul Nougé.

The artistic and above all intellectual center of gravity for Belgian avant-garde artists as for others, was of course Paris, where Magritte moved in 1927 with his wife of five years, Georgette. In Brussels he had experimented with forms of Synthetic Cubism and created pictures in which the collage principle was translated into flat patterns, but in Paris Magritte became involved with Surrealism. Entry into the inner circle around André Breton, head and ideologue of the group, was not immediate, nor, independent-minded as he was, did Magritte appear to seek it. He was himself leader of a still-to-be-constituted movement in modern painting that differed in many respects from that of the Paris Surrealists. Thus it may be symbolic that instead of settling in the center of the French capital, Magritte established himself on the outskirts at Perreux-sur-Marne, east of Château de Vincennes.

Nevertheless, in the following years Magritte sought to make a name for himself in the Paris art world that centered around Breton. He soon came to know other figures in the new movement, including Max Ernst and Joan Miró. His first close friend there was Camille Goemans, a poet and author who had likewise moved from Brussels to Paris, and who had settled in Montmartre. Through him Magritte met Hans Arp, for whom Magritte's wife sewed the cords on a number of string reliefs.

But the decisive event for Magritte was Giorgio de Chirico's painting *The Song of Love,* which he saw reproduced in a magazine (fig. 1). Magritte later recalled the epiphany he had felt upon seeing the work: "This triumphant poetry supplanted the stereotyped effect of traditional painting. It represented a complete break with the mental habits peculiar to artists who are prisoners of talent, virtuosity, and all the little aesthetic specialities. It was a new vision through which the spectator might recognize his own isolation and hear the silence of the world."[3]

Even in this statement we can sense the enormous impact that de Chirico's work had on Magritte. Nor was he the only one in the Surrealist movement to have been struck by the Italian artist's mysteriously poetic and radically anti-perspectival painting. One need only recall Max Ernst, whose Dada portfolio *Fiat modes, pereat ars* of 1919 is unthinkable without de Chirico's influence. Only gradually did Breton begin to consider Magritte's work for the "official" Surrealist publications, or mention it in their announcements. Still, respect for the painter with the harsh Walloon accent grew.

## MAGRITTE, SURREALIST

In the twelfth issue of *La Révolution surréaliste,* published in December 1929, Magritte was represented by several contributions, the most famous of which is the photocollage with his painting *La Femme cachée* (The Hidden Woman) in the center, surrounded by photographic portraits of members of the Surrealist group (fig. 2). All were photographed

with their eyes closed, as if Magritte's nude figure were appearing to them in a dream. The 1929 collage paraphrased a celebrated collage of the murderer Germaine Breton surrounded by photos of the Surrealists, which had been published in the first issue of the magazine in 1924. This 1929 issue had a similarly programmatic aim as the first, since it included Breton's "Second Manifesto of Surrealism." In addition, the group had since undergone considerable change, for apart from the increased influence of the new member from Brussels, Dalí in particular was providing new impetus.

The political thrust of the Surrealist movement had waned, giving way in particular to themes of "love" and "woman." Stylistic approaches shifted accordingly, from psychic automatism to the magic realism of the two new protagonists, both of whom had begun their Surrealist careers under the spell of Giorgio de Chirico. With his painting surrounded by the heads of the group's members, Magritte provided a kind of icon for the second phase of Surrealism. The composition featured the two characteristic components of Magritte's art of that period: a reflection on the feminine, and the issue of the relationship between image and text.

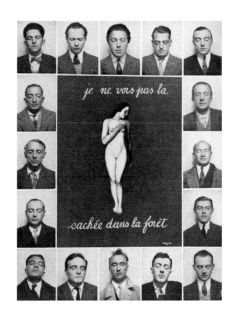

FIGURE 2
Photocollage from *La Révolution surréaliste,*
no. 12, 1929

Magritte's written words have the look of some naive, childish exercise on a school blackboard. But despite their innocent appearance they are capable of plummeting the spectator into the abyss that yawns between the sign and the painted object, between illusion and representation. "This is not a pipe"—the phrase in the famous word-painting mentioned above—triggers both a visual and intellectual shock in the viewer's mind. After an initial attempt to shrug it off as a visual pun or joke, we gradually become aware of its implications. This is no rebus of the type once popular in illustrated magazines, for the rendering of the pipe is anything but casual or illustrative. The image seems to grow in intensity. With this, it seems to me, we have pinpointed an aspect of what I call the Magritte effect. In addition, the anonymous, as it were authorless, style of Magritte's paintings differs from that of earlier modern artists, who had combined script with visual representation of objects.

## WORDS IN PICTURES

As remarkable and unique as Magritte's paintings with writing may seem, they were by no means the first such works in modern art, indeed words were combined with images very much earlier. The inscribed names on painted and carved figures in the Middle Ages, the inscriptions on allegories, the mottos on emblems, and the textual quotations in history paintings, are examples of the equally matter-of-fact and varied uses of words to name, explain, and interpret visual imagery.[4]

There are a few paintings that show a particular relation between picture and inscription, and these have become oft-cited examples of the interface between painted illusion and verbal statement. Jan van Eyck's *Arnolfini Portrait* has a famous inscription reading "Johannes de eyck fuit hic—1434" (Jan van Eyck was here—1434)

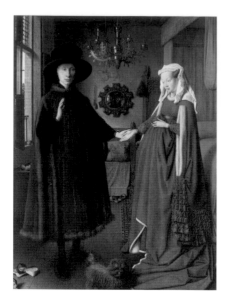

FIGURE 3
Jan van Eyck
*The Arnolfini Portrait*, 1434
National Gallery, London

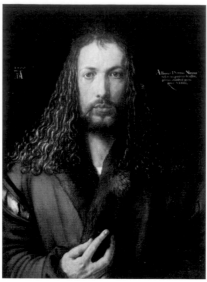

FIGURE 4
Albrecht Dürer
*Selbstbildnis* (Self-portrait), 1500
Alte Pinakothek, Munich

(fig. 3). Thanks to an equally renowned interpretation by the art historian Erwin Panofsky, the meaning of this signature was decoded as the underwriting of a wedding rite by a witness. No less suggestively did Albrecht Dürer record his signature, the date and his age, next to his self-portrait with Christ-like head (fig. 4).

If these two artists explained themselves, their role, and their function with the aid of writing, so too did Nicolas Poussin over a hundred years later, when he lent a voice to his 1650 self-portrait, now in the Musée du Louvre in Paris. In another work Poussin employed a different kind of textual quotation with the phrase "Et in Arcadia ego" inscribed on a sarcophagus in front of which shepherds discuss and attempt to interpret the meaning of the words.

With the end of that era, the various uses of inscriptions in paintings disappeared, though Jacques-Louis David's inscription "A Marat" may seem like a chiseled reminiscence of the classical age (fig. 5). The French Revolution brought down this ancient view of the world, and in its place brought forth the social, scientific, and materialistic view that characterizes the modern era. Visual art fought for autonomy, first from literature, then from appropriation by society. This is why it would seem absurd to find Manet penning a pastoral verse in *Le Déjeuner sur l'herbe,* or to think that Paul Cézanne intended his views of Mont St. Victoire to be seen as topographical descriptions.

Gradually, words reentered art, when the Cubists began to include carefully selected and labeled objects in their still lifes. However, the question immediately arises as to the relationship of these written or printed elements to the fragments of objects by which the Cubists set such store. On the one hand, newspaper titles, concert programs announcing the work of Bach or Mozart, the names of objects, and actual pieces of newspaper used as collage elements, reflected the artists' Paris milieu: cafés, cultural events, studios, and so on. On the other hand, the words played a role in the complex and changing space of Cubist investigations, in which the illusion of three dimensions made way for planar values, though between the flat fragments and polyfocal views of objects there

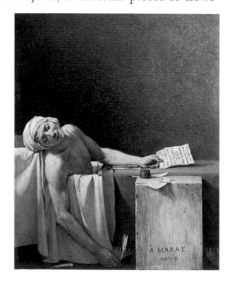

FIGURE 5
Jacques-Louis David
*Marat assassiné* (Death of Marat), 1793
Musées royaux des Beaux-Arts de Belgique, Brussels

lurked a new pictorial mystery. So for the Cubists, lettering and typography can have both a descriptive, affirmative function, and an ironic and disjunctive function.

Around 1911–12, in the wake of Picasso and Braque, Max Beckmann, Paul Klee, Marcel Duchamp, and Francis Picabia introduced words into their pictures. In 1915 Picabia even flattered a machine part with the inscription "Voilà la femme" (fig. 6)! In its radicalness this discrepancy between text and image already points forward to Magritte. But while Picabia's juxtaposition demonstrates the gap opened by wit and imagination, it does not yet open the gulf within the categories of signs per se, which Magritte would soon exploit.[5]

The paintings by Magritte that incorporate words and images have been called "script paintings," works that contain written elements and that also show a link between writing and abstract form, such as *La Preuve mystérieuse* (The Mysterious Proof) of 1927 (pl. 25), and *Les Reflets du temps* (The Reflections of Time) of 1928. In these compositions, concepts are related to abstract shapes that bear a certain resemblance to those in Joan Miró's paintings of the mid-1920s. Of course the words written in precise longhand have no substantial relation to the abstract, vaguely biomorphic forms with which they are associated.

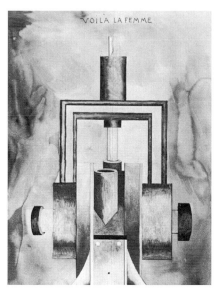

While in earlier paintings Magritte had adopted the collage principle to produce spatial scenes along the lines of de Chirico—as in *La Naissance de l'idole* (The Birth of the Idol) of 1926 (pl. 5), or *Le Visage du génie* (The Face of Genius) of 1926 (pl. 6)—here he supplemented the unexpected juxtapositions with an enigmatic, dark space and correspondingly subdued colors. The script paintings remain dark and indeterminate, as if they had resulted from the tentative probings of a creator still considering the best way to lend order to the world. Neither the arbitrariness of collage, nor the logical, iconic shock of the following phase in Magritte's work, appear in this group of works, whose approach was to resurface in the mid-1930s, metamorphosed into a neat, realistic style, for which *Le Sens propre* (The Literal Meaning) of 1929 (pls. 26, 27), may serve as an early example.

Nevertheless, the script paintings revealed for the first time Magritte's unique vision and the strength of his position within Surrealism. In attempts to define and categorize Magritte's art, a statement by Max Ernst is often quoted, to the effect that Magritte's works should be understood as "collages painted entirely by hand." Now Ernst made this statement in the context of a collage exhibition, and cogent as it may seem, it cannot really be extended to cover Magritte's œuvre as a whole. Magritte is anything but an anarchist out to reorder the world in his collages, as has been said of Picasso.[6] By means of his method of visual thinking Magritte does bring words and images into a new position with respect to one another, but his intentions are fulfilled solely through painting sui generis.

Magritte often spoke of his pictures as being solutions to certain problems of visual thinking. In his thinking, there was no room for the effects and sometimes arbitrary nature of collage. Nor do chance or the particular qualities of materials come into play with Magritte as they do, for example, with Hans Arp and Max Ernst. What appears incredible or "super-real" in his imagery is brought about through exact calculation, as witnessed by his numerous preparatory drawings and the many repetitions of certain motifs.

The problem of the script paintings culminated in *La Trahison des images* (The Treachery of Images)—also known as *Ceci n'est pas une pipe* (This Is Not a Pipe)—of 1929 (pl. 21), which the French philosopher Michel Foucault took as his point of departure for a famous essay investigating Magritte's work in the context of larger philosophical issues.[7] For Foucault, Magritte's work was, paradoxically, interesting from the point of view of his theory of signs, leading him to consider the artist's enigmatic imagery in relation to that of Paul Klee and Wassily Kandinsky, and demonstrating a shift away from representational painting. For Foucault, Magritte rejected the harmony of signs that typifies the classical age, and which is represented, in Foucault's discussion, principally by Diego Velázquez.

It must be said, though, that Foucault misjudged certain aspects of Magritte's work, and in the correspondence begun by the artist after reading Foucault's *Les Mots et les choses* (first published in 1966 and subsequently translated into English as *The Order of Things*), misunderstandings abound.[8] On the basis of what he knew about Magritte, the philosopher was unable to comprehend the full meaning of the artist's key concept, resemblance. For Magritte, resemblance offered a means for transcending the ordinary, and instead suggesting the mystery of life. This covert Platonism of Magritte's remains completely alien to Foucault, who instead perceived a "delirium of signs," something that in turn must have been entirely alien to the sober Magritte, a Surrealist of quite a different persuasion than that of the Parisian avant-garde.

Magritte's imagery retains a link with the infinite and the mysterious, which makes it possible to detect religious undercurrents in his work.[9] His critique is a visual critique directed against bourgeois thinking and behavior. His realism is deployed in an attempt to get behind the appearance of things. Here, by the way, is the point of closest contact between Magritte and Max Beckmann. Yet while Magritte's Platonism tends to be a positive one, Beckmann's is more of the Gnostic variety.

## THE ARTIST OF THE EVERYDAY

In many of Magritte's paintings there appears, like an emblem, a man seen from behind, wearing a black coat and a bowler hat. Similarly normal 1920s figures are found in other works of visual art, especially in film, with which Magritte's man has often been connected. In fact the compositional methods he employed from the 1930s onward do in many cases recall the technique of the cinematic fade or double exposure.

The man in the hat can be interpreted as a self-portrait, though in other respects Magritte tended to be very discreet about his private life. His wife, Georgette, often appears in the paintings, and the backgrounds occasionally offer glimpses of their modest Brussels flat. Magritte's demeanor was that of a "Mr. Ordinary" who worked his daily round like everyone else and neither courted nor expected particular attention.

It has often been noted that Magritte preferred not to be called an artist. His flat at 135 rue Esseghem in Brussels doubled as a studio. He had moved there from Perreux-sur-Marne in 1930, after falling out with Breton, and was to live with his

wife in this modest and typical Belgian apartment until 1954. In contrast to Max Ernst's busy social life with Peggy Guggenheim, or to Salvador Dalí's eccentric life with Gala, René Magritte slipped into the role of the honest burgher who quietly plied his craft.

Apart from his self-styled role of retiring artist there were, however, financial reasons for Magritte's humble lifestyle. Without Georgette's earnings, they would have had difficulty making ends meet. Much negative comment has been made about the variants and copies Magritte made of his earlier, most successful works. It is said that he executed commissions like a skilled manual worker, and that he sometimes neglected the quality of his workmanship. This may be true in part, and it is true that Magritte had repeated discussions on this matter, particularly with his American dealer, Alexandre Iolas, who often asked for reworkings of popular themes. Yet Magritte knew of the risks involved, and reacted peevishly or reservedly to such requests.

In a positive sense, however, many of the repetitions include minor changes which serve to focus the visual idea and heighten its effect. In other words, Magritte would rework certain themes in an effort to improve them. Taken together with his studies, this procedure can be seen to have relied not on the brilliant gesture but on a thinking more akin to that of a constructor, arranging and rearranging visual elements until they produced a shock like a blow from a boxer's glove—whose force, however, remained purely visual and mental.

The Cubists were the first painters to approach their work in the manner of constructors. During their collaborative explorations, Picasso and Braque occasionally even dressed in mechanics' clothing. Like Magritte, they did not want to be considered as artists in the traditional sense. Léger, too, was filled with admiration for mechanics, builders, and engineers—in short, for everything technical—as was Robert Delaunay, whose optimistic view of technological progress led him to introduce the Eiffel Tower and airplanes into the iconography of modern art. The Wright Brothers were celebrated by the Cubists as prototypes of modern precision in thinking, research, and discovery.

A question that must be addressed is how Magritte viewed the work of Marcel Duchamp, who, from 1923 to 1934, devoted much of his time to playing chess. At least that was the persona Duchamp had in the eyes of the outside world, despite the fact that he continued to develop his ideas almost in secret in the studio. Although Duchamp surely did not consider himself a craftsman in the way that Magritte did, he had no desire to continue in the role of the artist as genius either. But he did manage to create an aura of mystery around himself, as is seen in the quirky but renowned photographs he posed for: Duchamp with a cigar, Duchamp seated opposite a naked woman at a chessboard and so on. "Duchamp's silence" was not without its message and resonance, and these were compounded by his activities as art dealer, correspondent, author, and so forth.[10] Magritte's reserve was of a completely different nature, lacking Duchamp's playful, ironic tone.

Magritte's *Golconde* (Golconda) of 1953 (pl. 62), is like an apotheosis of his typical, average man in the black coat and hat.[11] From a low vantage point we see a house frontage opposite and in the foreground, at the right edge, the cut-off corner of a building that seems to stand on our side of the street. Magritte's figures hover across the pictorial field, with the exception of the wall to the right. They float in the foreground and

in the distance, each seemingly on his own invisible little island in the air. The man in the bowler hat appears simultaneously to be an artificial figure and the artist himself, a traveler through pictorial space who experiences in everyday life the most extraordinary things—like Alice in a wonderland that likewise represented the obverse of normality.

## THE SEGMENTED WOMAN

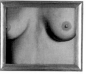
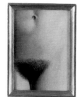

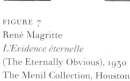
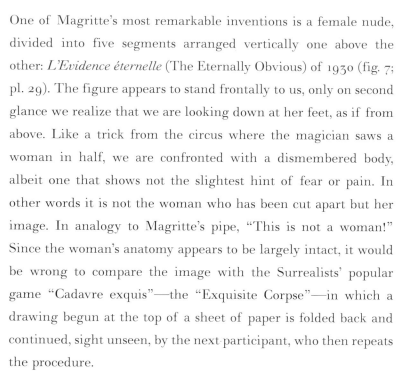

One of Magritte's most remarkable inventions is a female nude, divided into five segments arranged vertically one above the other: *L'Evidence éternelle* (The Eternally Obvious) of 1930 (fig. 7; pl. 29). The figure appears to stand frontally to us, only on second glance we realize that we are looking down at her feet, as if from above. Like a trick from the circus where the magician saws a woman in half, we are confronted with a dismembered body, albeit one that shows not the slightest hint of fear or pain. In other words it is not the woman who has been cut apart but her image. In analogy to Magritte's pipe, "This is not a woman!" Since the woman's anatomy appears to be largely intact, it would be wrong to compare the image with the Surrealists' popular game "Cadavre exquis"—the "Exquisite Corpse"—in which a drawing begun at the top of a sheet of paper is folded back and continued, sight unseen, by the next participant, who then repeats the procedure.

The way this female figure is imprisoned in the frames instead calls to mind the most renowned female nude in early Northern European painting, Jan van Eyck's *Eve* on a wing of the multipartite Ghent Altarpiece (fig. 8). Magritte presents his "Eve-Georgette" unprotected to our gaze, even riveting our attention by means of fragmentation; the segmented figure's body seems close enough to touch, yet at the same time resists this desire in a way that is hard to describe. It has become an image, a representation full of artificiality and painterly virtuosity that never disguises its fictional character. Herein lies the special quality of this visual ensemble. By dividing the body into pictorial segments Magritte underlines his declaration that "This is not a body!" There could be no more subtle way of demonstrating the equivocal relationship between painting and reality.

The theme of Eve or Venus has been repeatedly employed by artists since the Renaissance to create what might be called visual treatises designed to demonstrate their theories of beauty, their attitude to mimesis, and their own importance and rank. Dürer's *Adam and Eve,* Giorgione's *Venus,* Titian's *Venus,*

FIGURE 7
René Magritte
*L'Evidence éternelle*
(The Eternally Obvious), 1930
The Menil Collection, Houston

FIGURE 8
Jan van Eyck
*Eve* (detail of *Ghent Altarpiece*), 1425
St. Bavo's Cathedral, Ghent

18

Velázquez's *Rokeby Venus*, Manet's *Olympia*, Ingres' *La Source*, Cézanne's *Bathers*, Picasso's *Les Desmoiselles d'Avignon*, Braque's *Grande nue*, Matisse's *Luxe, calme et volupté*, and many other masterpieces down to Duchamp's *Bride Stripped Bare*, combine to produce the impression that beauty in painting must necessarily be feminine in gender.

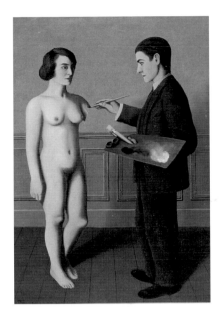

In contrast to the collage reproduced in the Surrealist journal of 1929, Magritte's woman has now, in 1930, awakened and, as it were, presented herself to the eyes of the artist, who simultaneously creates her and is dominated by her. We are immediately put in mind of the famous painting of 1928, *Tentative de l'impossible* (Attempting the Impossible) where Magritte depicted himself in the process of creating Georgette as a living figure in pictorial space; he is seen just beginning her left arm, which gradually flows from his brush (fig. 9). Depiction is presented as a magical process made possible by painting. In this uncanny painter-and-model scene, which has nothing of the erotic frisson of similar themes treated by Picasso, Magritte seems to integrate the female principle into his life and work. The haunting image of his dead, naked mother, which cast a shadow over his earlier work like an apparition from a nightmare, has been overcome.

As late as 1926 Magritte had still addressed the terrible event of his mother's suicide, in *Les Rêveries du promeneur solitaire* (The Musings of a Solitary Walker). It also echoed in *Les Amants* (The Lovers) of 1928, where the heads of the kissing couple are bizarrely covered with white cloths, lending them a resemblance to the stone-carved mourners in Dijon by the late-medieval sculptor Claus Sluter. Further examples dating from 1928 are *La Ruse symétrique* (The Symmetrical Trick) and *L'Histoire centrale* (The Central Story) (pl. 14). Magritte's surrealism is shot through with theatrical effects, such as scenes where characters are deprived of sight in order to give the situation a comical, tragic, or confusing turn. The viewer is confronted with a strange game of blindman's buff, which serves to highlight the incompatibility of human beings and everyday objects. This gives rise to riddles that are suggestive of a plot, albeit a vague and fragmentary one. The bizarre and unexpected are often accompanied by what appears to be a crime story, as in the famous *L'assassin menacé* (The Murderer Threatened) of 1927, which was inspired by the film *Fantômas*. It is Magritte's way of catching the sudden, pregnant moment that makes many of his paintings of the 1920s so remarkable and inexplicable. In order to augment the effect, Magritte had already begun to divide his pictures into several parts, though without giving them actual separate frames as he would do in *L'Evidence éternelle*.

In the paintings *L'Idée fixe* (The Obsession) and *L'Espion* (The Spy; pl. 21), both of 1928, Magritte used sections like pieces of a puzzle belonging to some mysterious and possibly criminal act. The method of partitioning was also employed in word-pictures in which simple objects were accompanied by "false" names. These multipartite images recall the formats of altarpieces, and also Marcel Duchamp's *Fresh Widow* of 1920, though in that work the green-framed fields are solid black, contain no motif, and have the effect of blind windows.

Comic strips and the old illustrated stories or broadsides from Epinal worked with such narrative boxes, in which a plot develops with the jerky steps of a badly

19

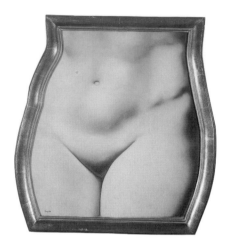 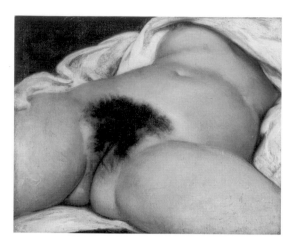

FIGURE 10
René Magritte
*La Représentation*
(Representation), 1937
Scottish National Gallery
of Modern Art, Edinburgh

FIGURE 11
Gustave Courbet
*L'Origine du monde*
(The Origin of the World), 1866
Musée d'Orsay, Paris

edited movie. For Magritte, the device of demarcated fields and the multiple parts made the paintings more like independent objects. This relates to the Surrealists' fascination, from around 1930, with "object sculpture" in which found items were presented as art objects in their own right. The most surprising example of Magritte's work in this vein is probably *La Représentation* (Representation) of 1937 (fig. 10; pl. 32), the frame of which is shaped in the form of the lower part of a woman's torso.

20

The hidden woman presents her sex, which ultimately becomes a synonym for "representation" per se. In this work, the ideal of feminine beauty becomes an object. It may be compared to *The Origin of the World*, Gustave Courbet's painting of a woman's genitals (fig. 11).

### THE METAMORPHOSIS OF THINGS

During the 1930s Magritte's approach changed. He no longer concentrated on confrontations of basically incompatible words and objects. The semiotic character of the word-pictures, which had triggered Foucault's interest, made way for works that pivoted on the process of transition or transformation from one state into another. These works proved no less fascinating or extraordinary.

When objects began to replace abstraction and regain a greater significance in painting, due not least to Duchamp's influence, certain motifs in Magritte's art were reinterpreted to conform to this aesthetic *dernier cri*. These included *Le Modèle rouge* (The Red Model) of 1953 (pl. 39), which exemplified an approach known as the "metamorphosis of the thing."[12] What the viewer sees is a change in the appearance of the shoes, as they metamorphose into the feet inside.

The use of objects to stand for human beings was an allegorical procedure long familiar in art. For instance, Baroque iconography represented the suffering and death of Christ in the form of objects associated with the stations of his martyrdom: the cockerel that announced Peter's betrayal, the sponge on the lancepoint of the compassionate legionnaire, the cross, Christ's arms and legs displaying the stigmata, and so on. In the late nineteenth century, Vincent van Gogh became a master at investing objects with a personally

charged symbolism. This is why his own worn-out boots, painted in several works, were capable of sparking a debate that involved such illustrious intellectuals as Martin Heidegger, Meyer Shapiro, and Jacques Derrida. Magritte partially transformed the same humble things back into flesh and blood, in his own way confounding all established categories of objectivity.

But perhaps the most extraordinary example of transformation occurs in the painting *Le Viol* (The Rape) of 1934 (pl. 30). In this work we witness the metamorphosis of a woman's face into a female torso with breasts instead of eyes and a pubic triangle where the mouth should be. In this radical double-exposure of portrait and nude, Magritte seems to say that the sight of a woman's face can trigger a desire to see her body, provoking a mental image that overlays and becomes her face. Never before had he so suggestively expressed the link between object and perception, the projection of desires, and the incompatibility of perception with desire and lust. The background remains empty, the space being suggested by a horizon line between green landscape and a blue sky that grows darker toward the top. This lends the image a monumentality that prevents it from appearing merely witty or anecdotal.

A similar feeling of alienation is achieved in another work of the period, *In memoriam Mack Sennett* (In Memory of Mack Sennett) of 1936. Here a dress or nightshirt, visible in an open wardrobe, bears female breasts, again blurring the borderline between inanimate object and living being. The power of such metamorphoses proceeds from depictions of the female body, which in this way loses its individuality and instead becomes a nexus for transformation. Magritte would investigate this area in a number of new ways.

During the war and for a short period thereafter, the artist experimented with a new form of impressionistic painting and, a few years later, with a consciously ugly, roughly rendered imagery known as "la peinture vache" (literally, "cow painting") that has since caused considerable debate in critical writing on Magritte. Rejected by some as a lapse into tastelessness, the works of that phase became newly appreciated in the early 1980s, when pluralism in styles became more acceptable. The relationship between Magritte's "peinture vache" and Francis Picabia's work or William Copley's frivolous and witty imagery is obvious.

THE WEIGHT OF THE WORLD

What are we to make of things that are painted to appear weightless? What are we to make of a massive grey-blue rock, placed in the sky like some misshapen balloon? What sensations are triggered by a head covered in blue paint in which light white clouds drift by? What substantiality does a cloud have as it floats above a huge glass chalice that rises out of a river valley with mountains behind?

When solid, heavy objects are made to float, they create the impression of an apparition, a vision. Magritte accentuated this effect by presenting the hovering objects frontally to the viewer. Such apparitions are quite unlike the familiar painted depictions of

the visions of St. Francis of Assisi or of the Virgin in glory. The image itself is the apparition; it functions as an epiphany made real through paint, and Magritte goes to great lengths to lend these visions plausibility. But then we are confronted with a further effect, an alienation or displacement that pulls the solid ground from beneath the realism. The titles of the paintings also do their part to invalidate mimesis and transcend it.

The more one considers the nature of the Magritte effect, the clearer it becomes that in his paintings it is not humans but ordinary objects that are given an unusual role. A rock remains a rock, a rose a rose, an apple an apple. Things cannot slip into roles, and this is why they so clearly convey the illogical shock mentioned at the outset. But Magritte employs another and crucial tactic. Instead of giving the whole composition a sense of alienation, he makes only a single detail seem wrong, for example, a lightning bolt turned to stone.

Magritte's approach to metamorphosis eventually changed in the sense that rather than bringing objects and meanings into opposition, he sought to deprive objects of their natural gravity. At this point in his development—from about the early 1950s—it is evident that there is little substance to the charge often made against him, that he was not really a painter but a thinker. Whatever criticism can be made of his many repetitions of earlier motifs, which Magritte defended as attempts to improve on pictorial ideas, the paintings of the later years demonstrate a brilliant, varied approach which, especially in the passages that appear slightly out of focus, seem to anticipate and parallel the painting of Gerhard Richter.

To the extent that he sometimes ignored conventional floor lines, horizons, and so forth, Magritte liberated his painting from links with the probable to launch into the world of the impossible. This new world was increasingly situated in an intermediate zone that suggested the dreamlike and the visionary. This impression was increased by his frequent addition of white to the saturated colors. Though many artists began in the late 1950s to move away from abstraction and return to reality and concrete objects, Magritte's imagery left reality to enter, once again, an intermediate realm of dream and painted fiction. These works exemplify what Magritte had always described as the aim of his art: poetry.

This poetic ideal may convey a rather vague message to the viewer, who nevertheless senses that with Magritte, the poetic had a special meaning. First of all, it is safe to say that his poetry cannot be described as "poetic" in the traditional sense. Magritte's poetry does not aim to elicit an experience based on personal emotional reaction. There is a logical component in his poetics which consists, paradoxically, in a negation of the visual logic of experience. Metaphor, simile, symbol, illusion: none of these literary categories applies to Magritte who, moreover, continually defended himself against the idea that his imagery was supposedly painted thinking or painted literature. So what does poetry mean in connection with the experience of the Magritte effect?

Let us consider a painting like *La Présence d'esprit* (The Presence of Mind) of 1960 (fig. 12). Here the familiar man in the bowler hat and black coat stands between a bird perched on a tree stump and a vertical fish. Flanking the well-dressed man who looks out at the viewer, the bird and fish have a monumental presence. The fish hovers,

but there is no eye contact between the human figure and the "miracle" occurring right beside him. Only we as viewers experience the strange juxtaposition, which is absurd and yet made plausible by its precise rendering in paint.

The difference between this composition and earlier Magrittes of the late 1920s, for example, is clear. Here the discrepancy between image and reality no longer lies in the absurd theater of man and animal but in the apparition as such, and the way it is played out before our eyes. It is no longer a single element within the image of an otherwise logical reality that is exaggerated or displaced, but the entire scene, which has the character of an excerpt from some other poetic world, mysteriously introduced into our own world. Instead of informing the detail, poetry dominates the entire picture. The status of the imagery has changed. Magritte's late work brings confusion into the world of signs and at the same time loosens the bond between painting and reality.

For Magritte, poetry begins at the point where the probable and the familiar become mysterious. His poetry has nothing in common with the poetry in the art of the nineteenth century, in Eugène Delacroix's work for example, nor with the metaphysics of an artist like Caspar David Friedrich. It is rooted in the mysteries of human life, the life of the steel and coal region around Charleroi.

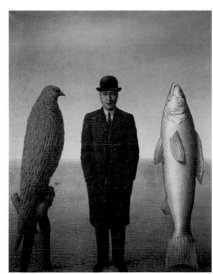

FIGURE 12
René Magritte
*La Présence d'esprit* (The Presence of Mind), 1960
Museum Ludwig, Cologne

23

*Translated from German by John William Gabriel*

NOTES

1. David Sylvester, *Magritte* (London: Thames and Hudson in association with The Menil Foundation, 1992), 9.

2. Louis Scutenaire, quoted in Sylvester, *Magritte*, 12.

3. Sylvester, ibid., p. 61, quoting from Magritte's lecture "La Ligne de vie," delivered in 1938.

4. See Michel Butor, *Les Mots dans la peinture* (Paris: Skira, 1969).

5. William A. Camfield, *Francis Picabia: His Art, Life, and Times* (Princeton, N.J.: Princeton University Press, 1979), esp. 71–90.

6. A detailed study of the script paintings is found in Christoph Schreier, *René Magritte. Sprachbilder* (Hildesheim, Zurich and New York: G. Olms, 1985) *Schriften sur Kunstgeschichte*, 33.

7. Michel Foucault, *Ceci n'est pas une pipe* (Montpellier: Editions fata morgana, 1973).

8. On the Magritte-Foucault correspondence, see also Karlheinz Lüdeking, "Die Wörter und die Bilder und die Dinge. Foucault & Magritte," in *Ethos der Moderne: Foucaults Kritik der Aufklärung* (Frankfurt am Main and New York: Campus, 1990), 280–307.

9. See Thomas Heyden, "Gott am achten Tag. Die Dimension des Religiösen bei Magritte," in *René Magritte. Die Kunst der Konversation* (Munich and New York: Prestel, 1996), 73–84.

10. Herbert Molderings, *Marcel Duchamp. Parawissenschaft, das Ephemere und der Skeptisismus* (Frankfurt am Main and Paris: Qumran, 1983), esp. 90 ff., concerning Duchamp's notion of the artist as missionary.

11. On this painting, see David Sylvester, "*Golconde* by René Magritte," in *The Menil Collection* (New York: Harry N. Abrams, Inc., 1987), 216–20.

12. Werner Haftmann, ed., *Métamorphose de l'objet: art et anti-art 1910–1970*, exh. cat., (Brussels: La Connaissance, 1971).

# PLATES

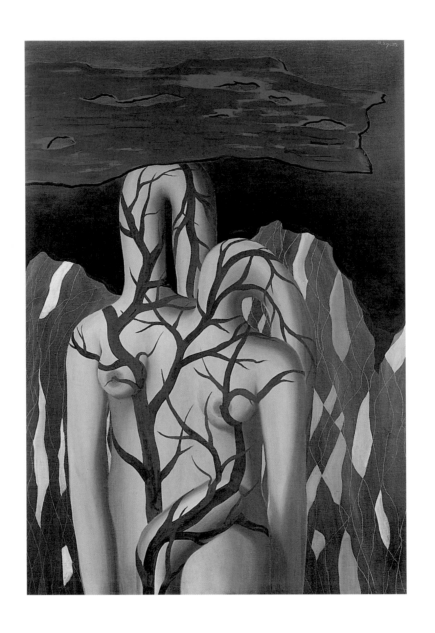

1
—
*Paysage*
Landscape
1927

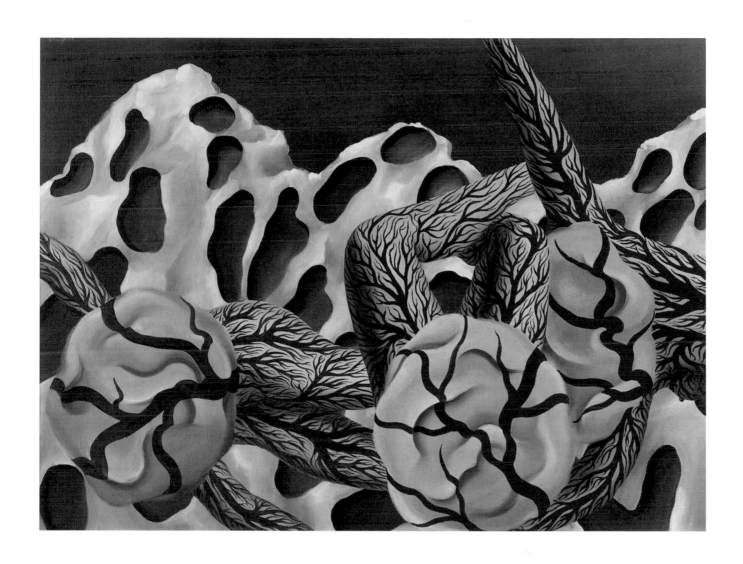

2

*Le Sang du monde*
The Blood of the World

1927

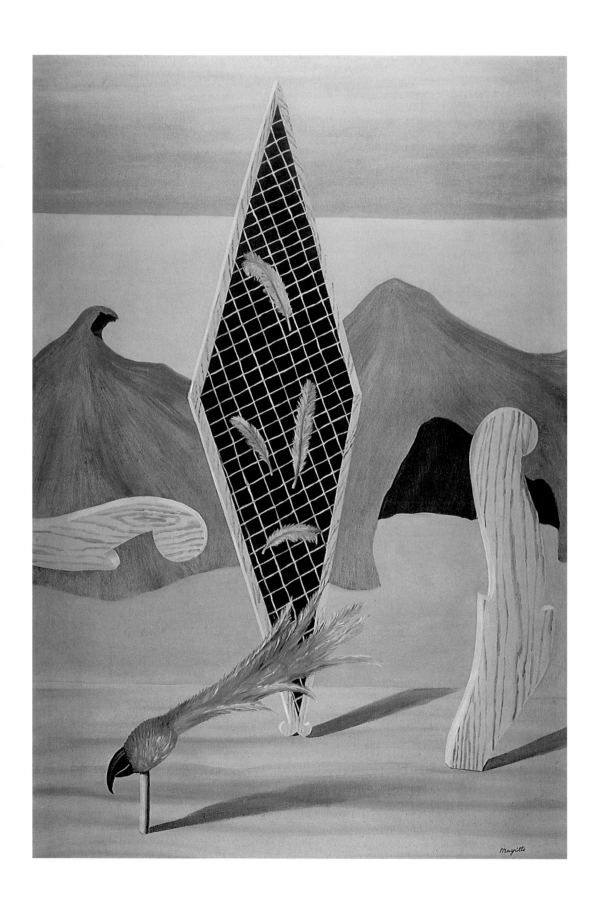

3

*Les Épaves de l'ombre*
The Wreckage of the Dark
1926

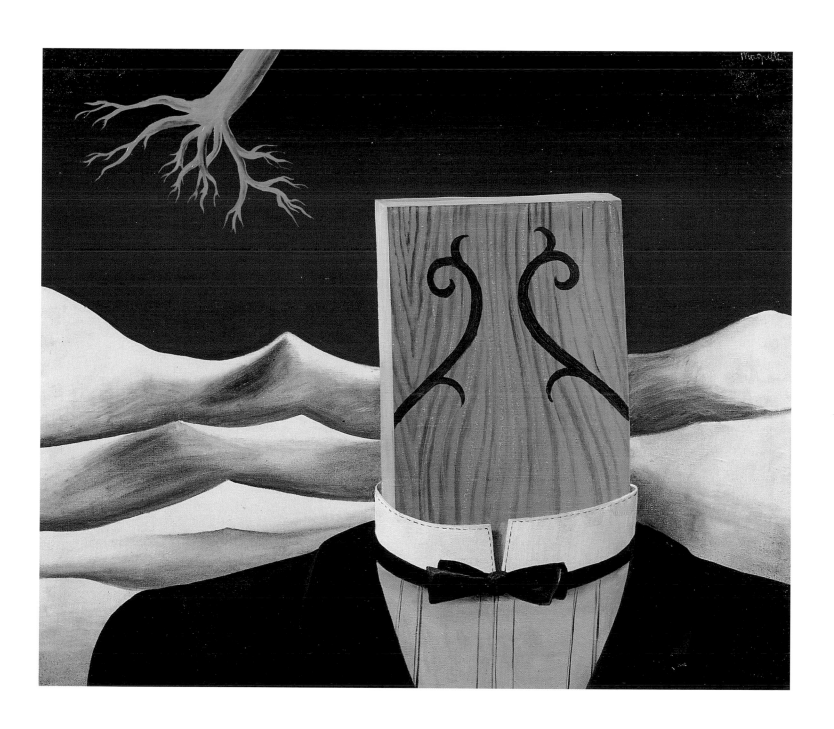

4

*Le Conquérant*
The Conqueror
1926

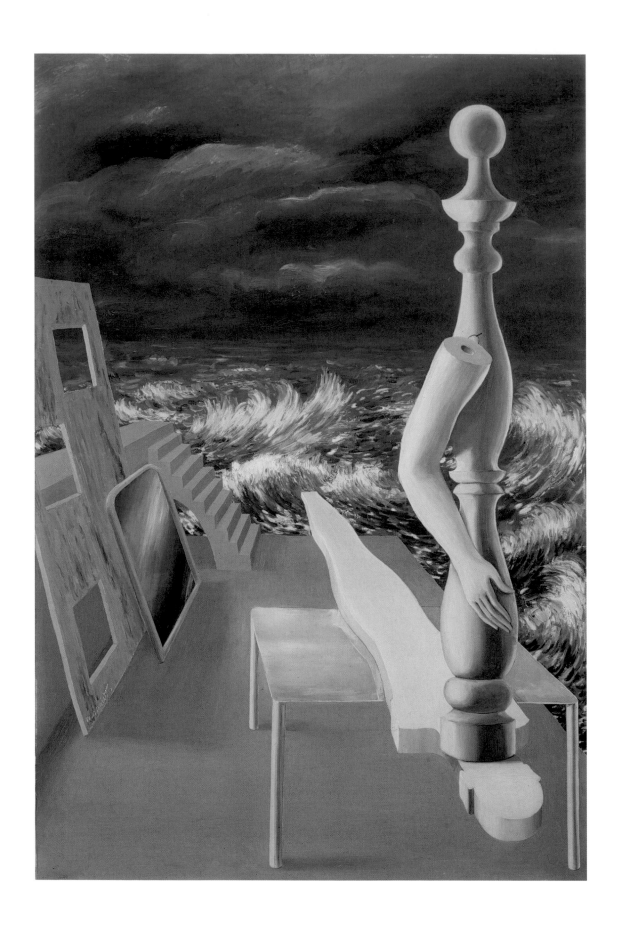

5

*La Naissance de l'idole*
The Birth of the Idol
1926

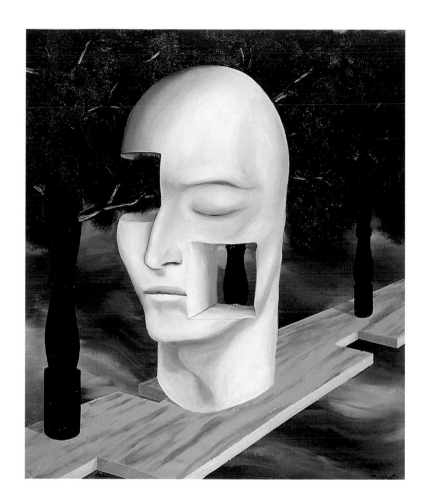

*Le Visage du génie*
The Face of Genius
1926

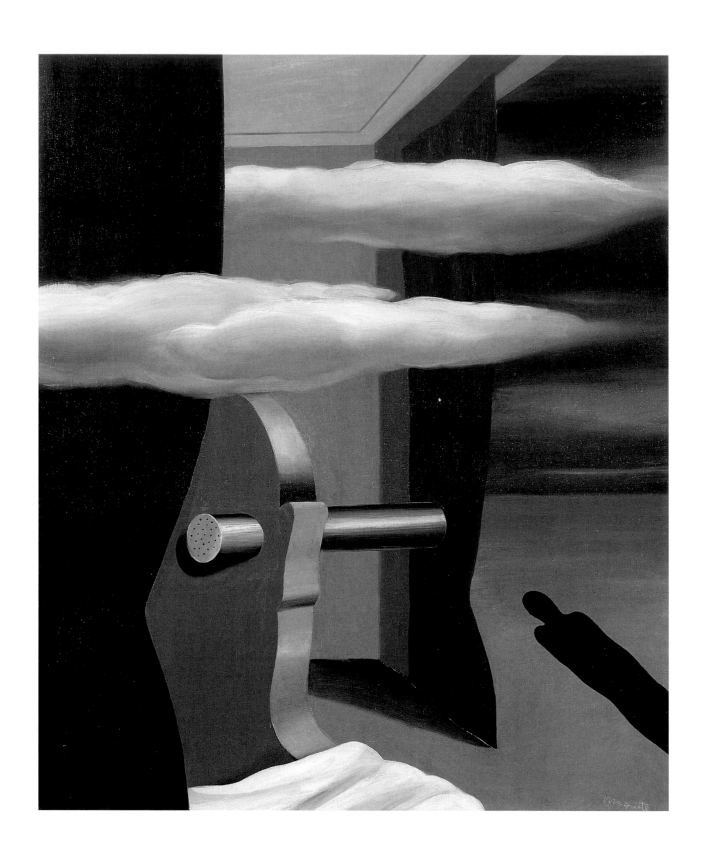

7

*La Catapulte du désert*
The Desert Catapult
1926

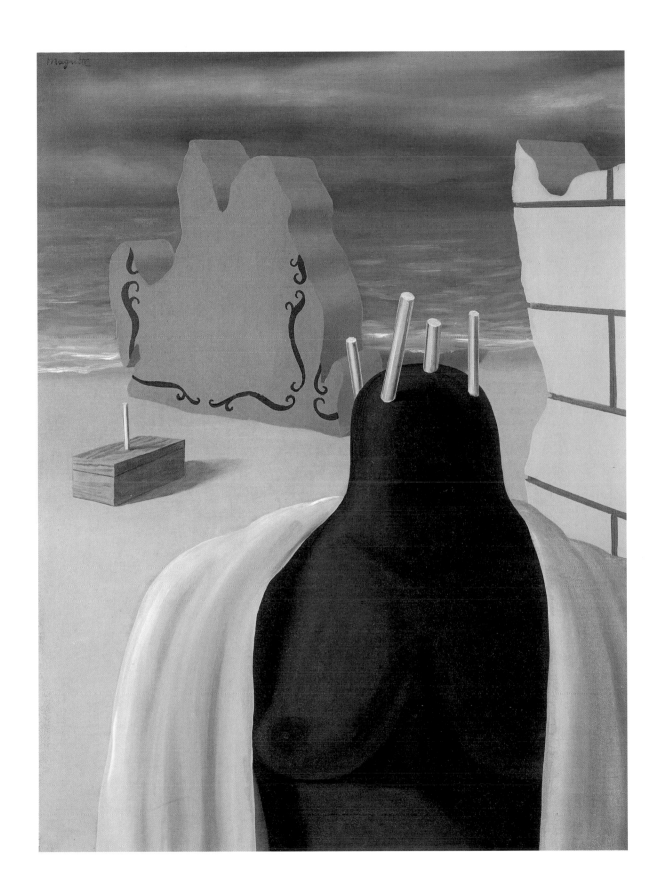

8

*La Supplice de la vestale*
The Torture of the Vestal Virgin

1927

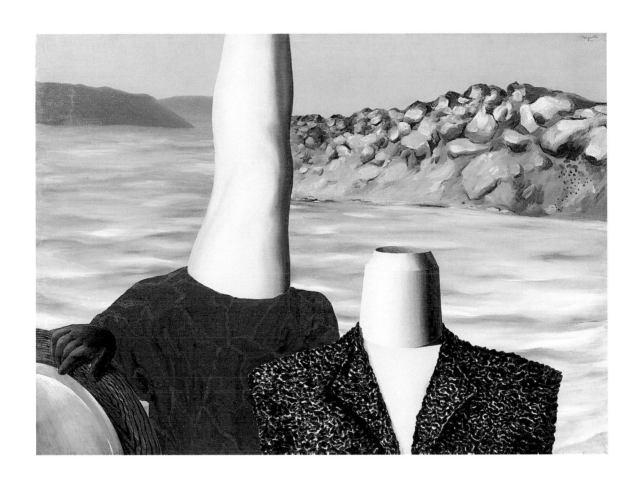

9

———

*Les Habitants du fleuve*
The Denizens of the River

1926

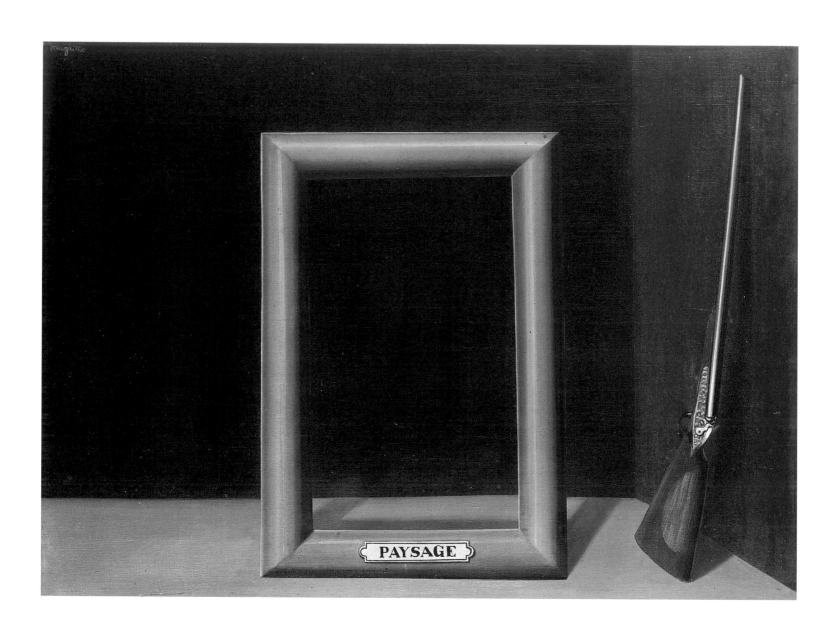

PAYSAGE

*Les Charmes du paysage*
The Delights of Landscape
1928

*L'Espion*
The Spy
1928

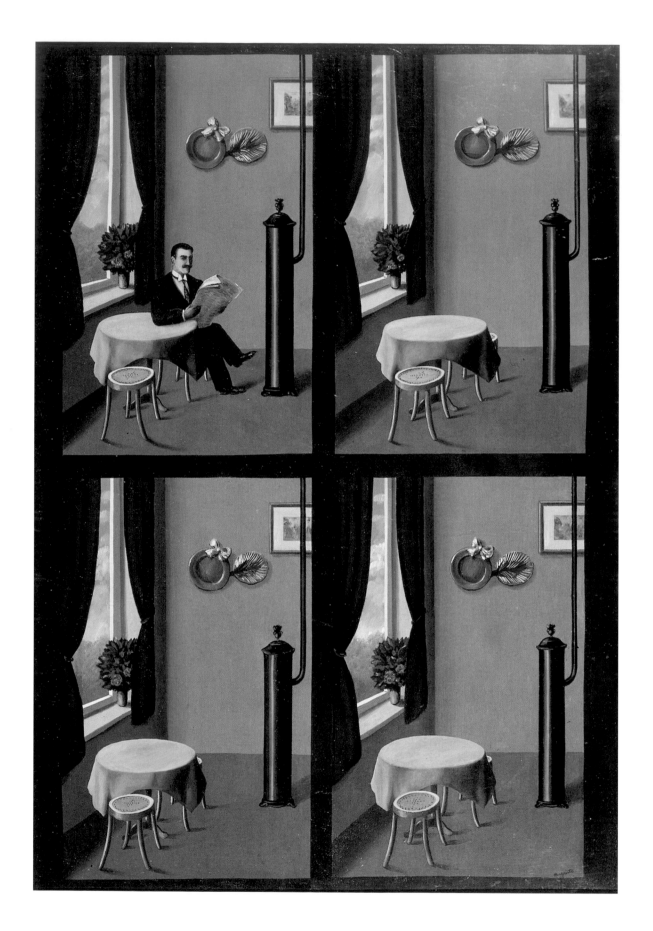

*L'Homme au journal*
The Man with the Newspaper
1928

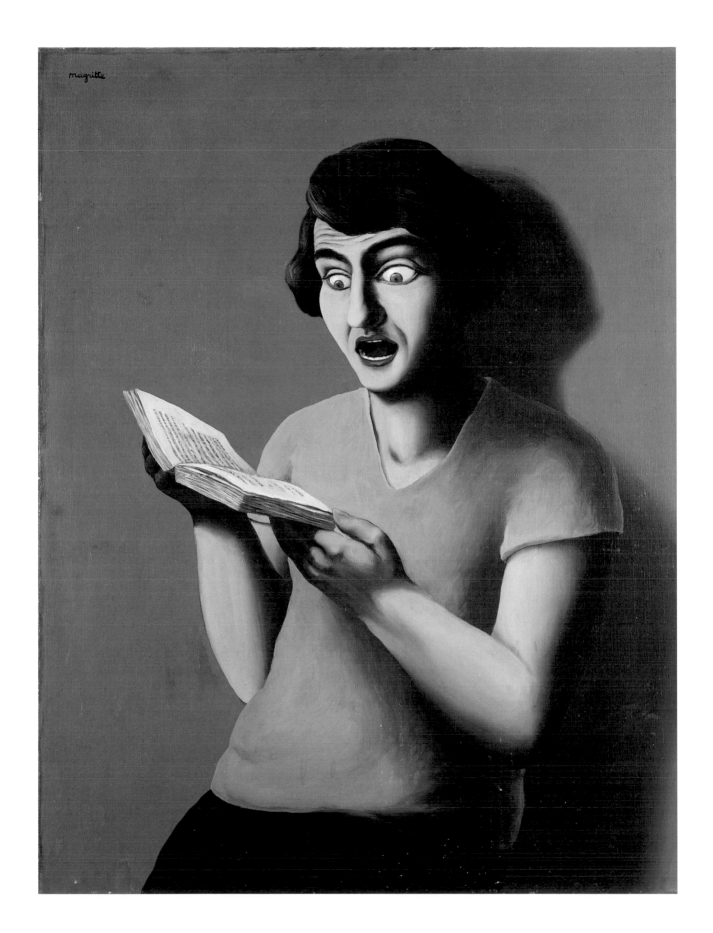

13

*La Lectrice soumise*
The Subjugated Reader
1928

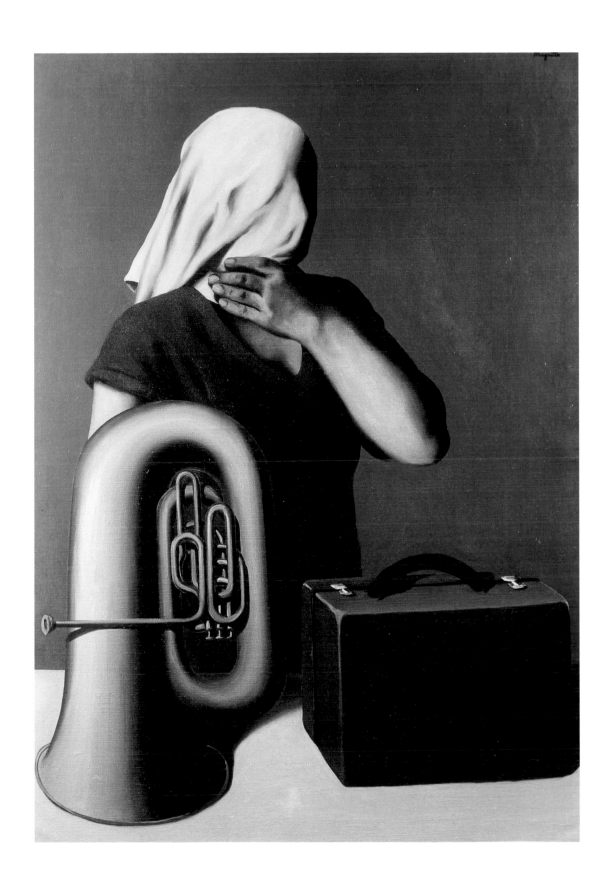

14

*L'Histoire centrale*
The Central Story
1928

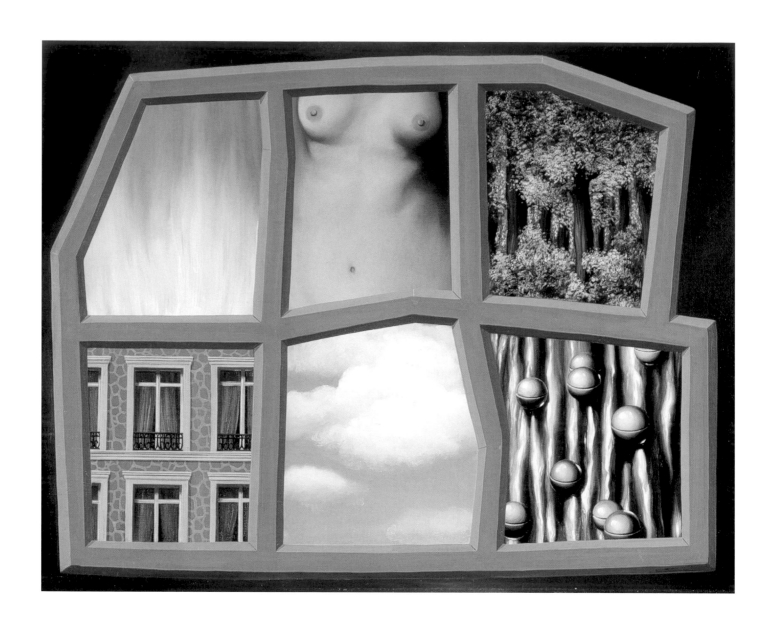

*Les Six Eléments*
The Six Elements
1929

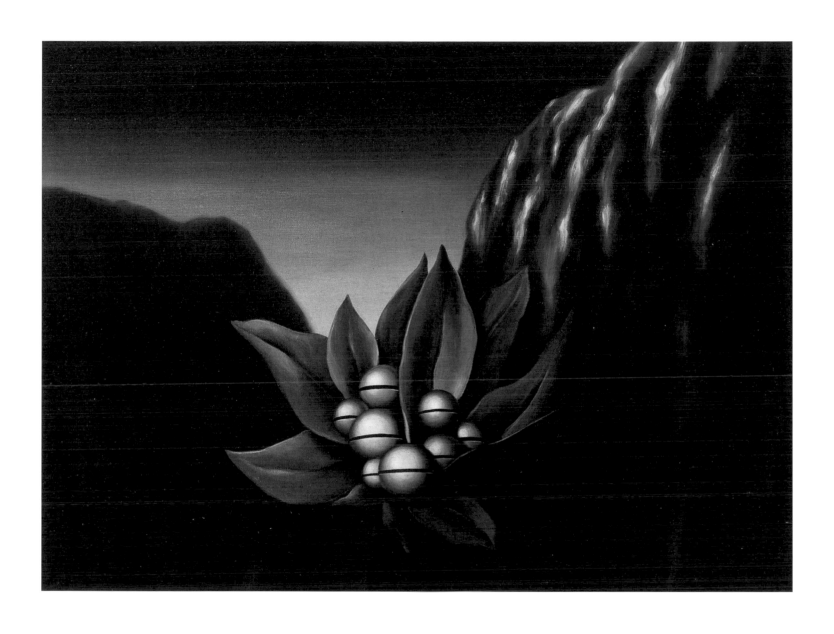

16

*Les Fleurs de l'abîme*
The Flowers of the Abyss
1928

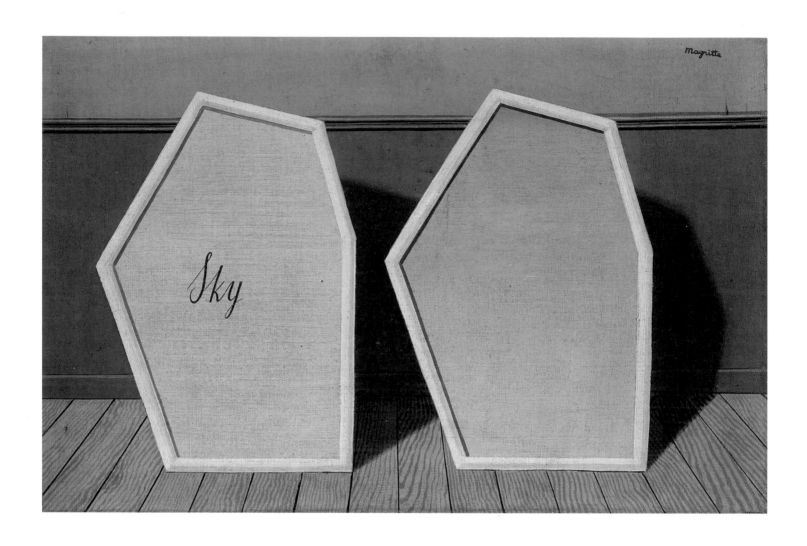

17

*Le Palais de rideaux*
The Palace of Curtains

1935

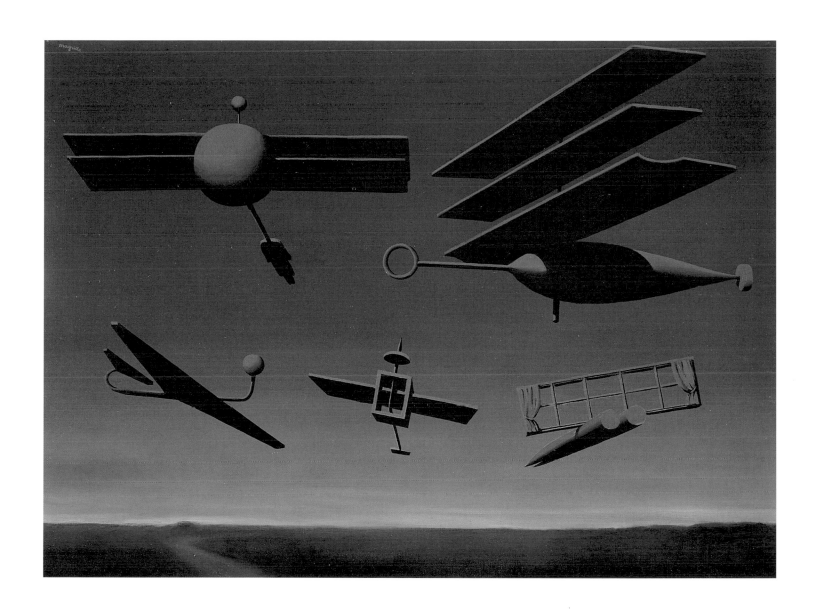

*Le Drapeau noir*
The Black Flag

1937

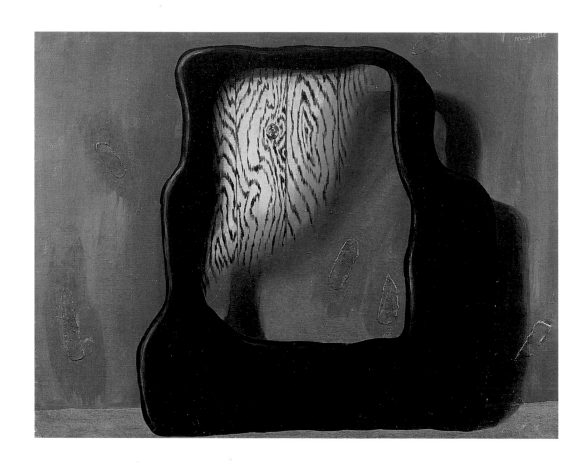

19

*Le Prince des objets*
The Prince of Objects

1927

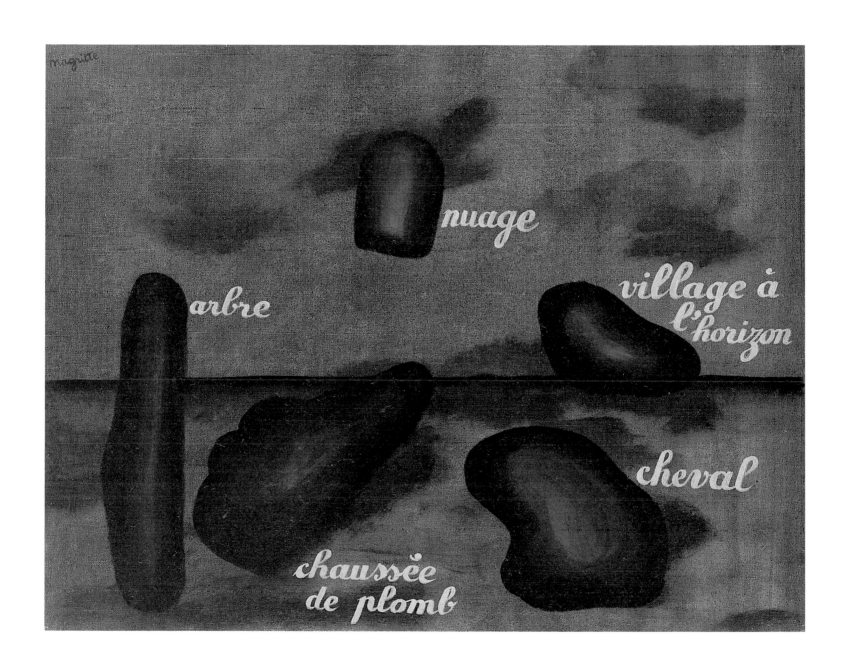

*L'Espoir rapide*
Swift Hope

1927

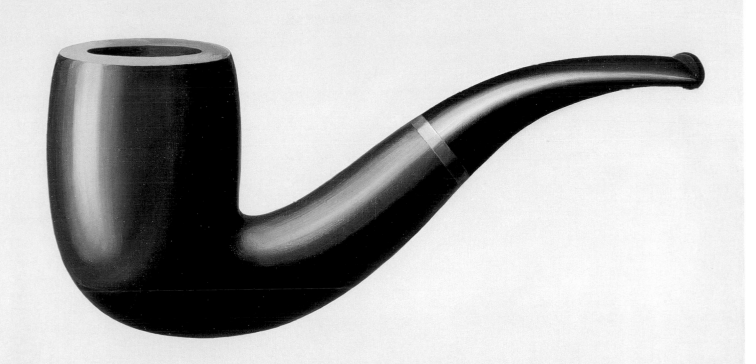

*La Trahison des images*
The Treachery of Images
1929

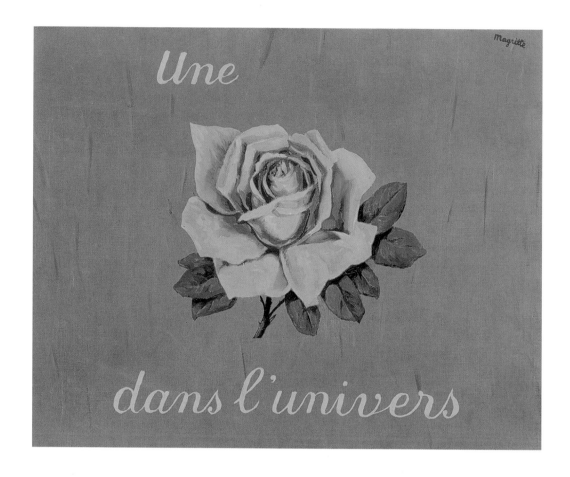

*La Voix de l'absolu*
The Voice of the Absolute

1955

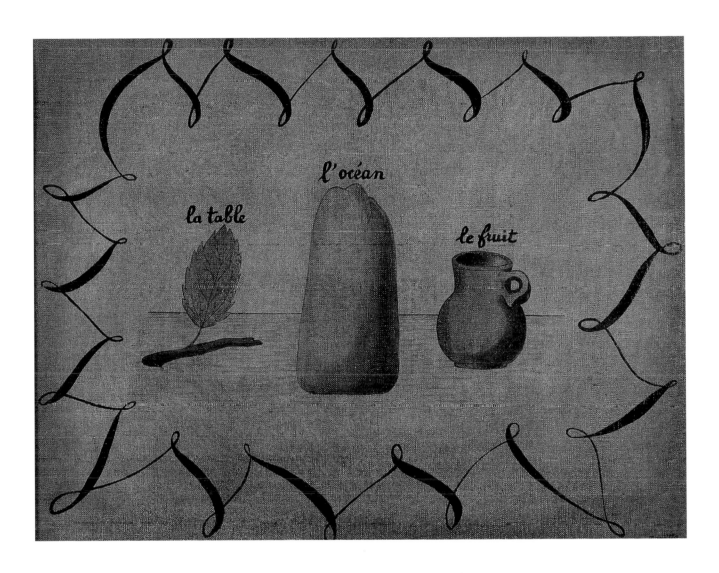

*La Table, l'océan, et le fruit*
Table, Ocean, and Fruit

1927

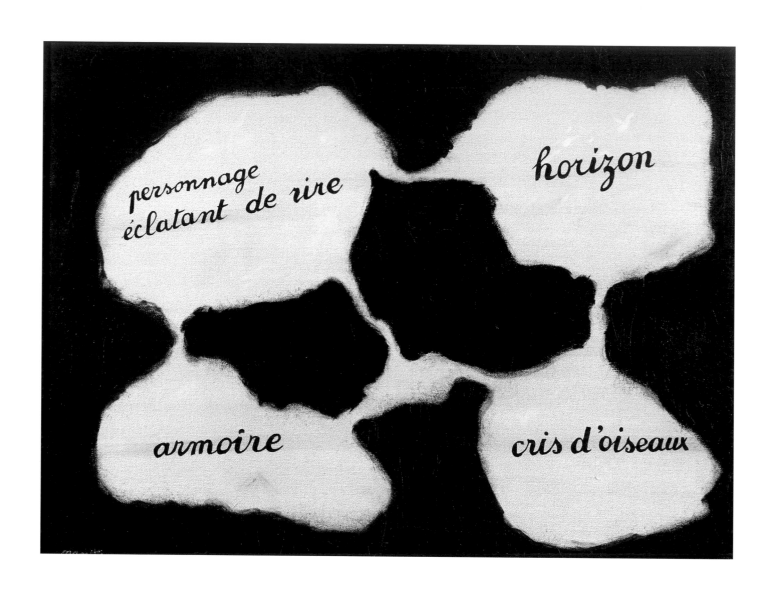

*Le Miroir vivant*
The Living Mirror
1928

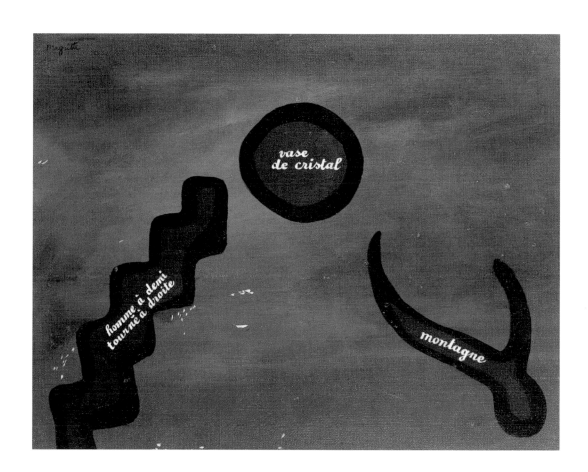

*La Preuve mystérieuse*
The Mysterious Proof
1927

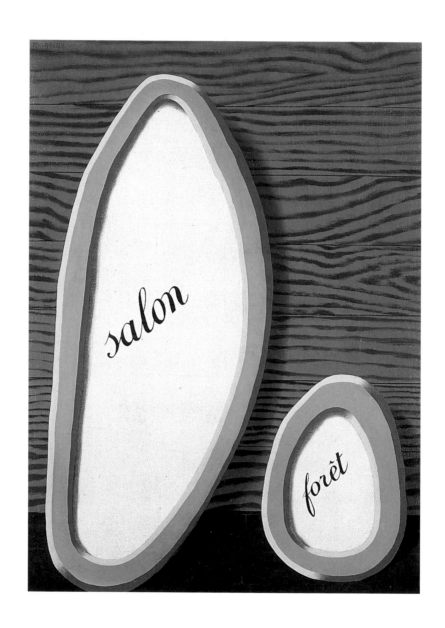

*Le Sens propre*
The Literal meaning

1929

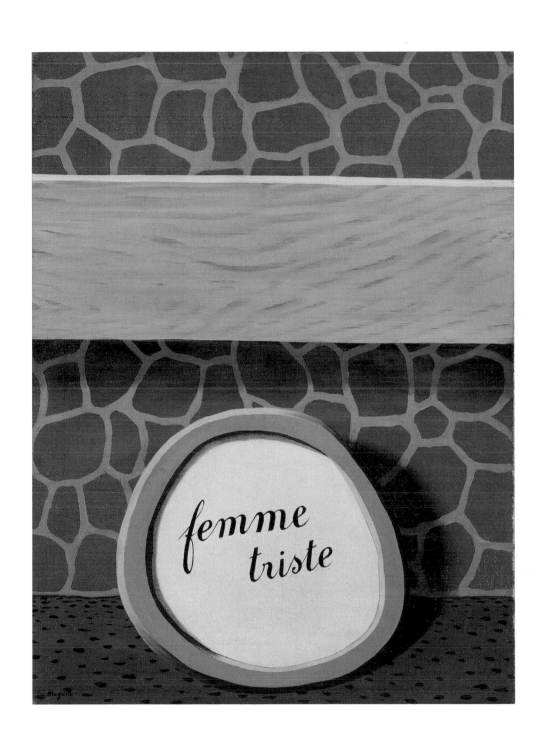

*Le Sens propre*
The Literal Meaning

1929

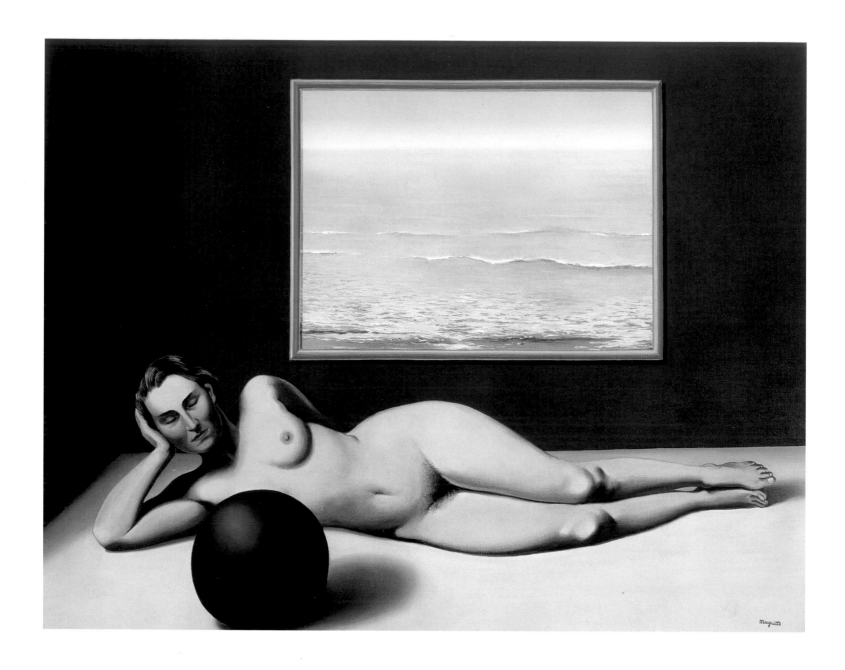

28

*Baigneuse du clair au sombre*
Bather between Light and Darkness
1936

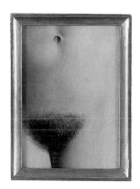

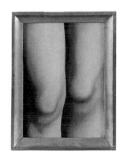

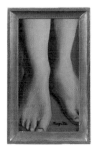

29

*L'Evidence éternelle*
The Eternally Obvious

1930

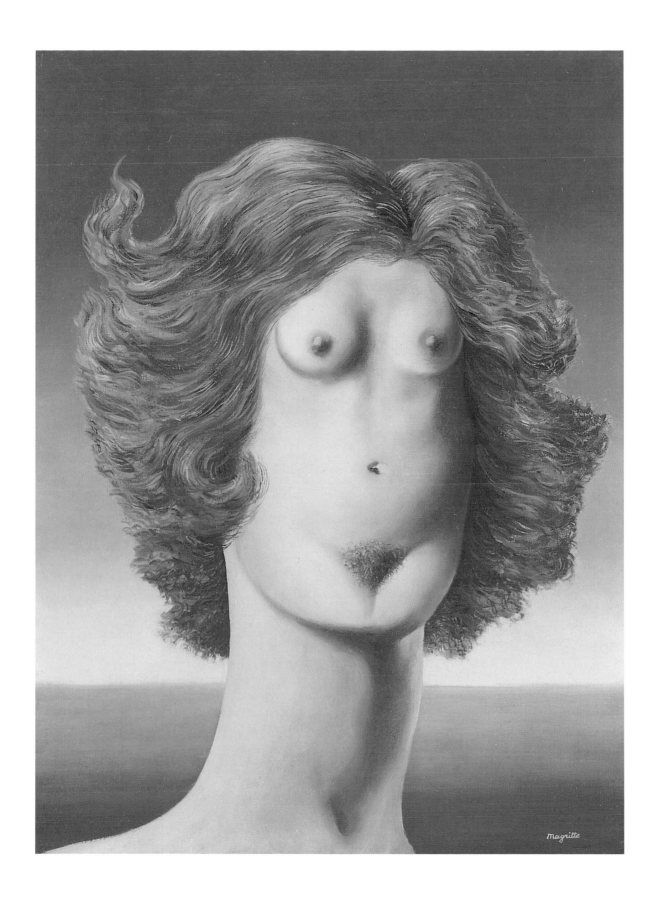

30

*Le Viol*
The Rape
1934

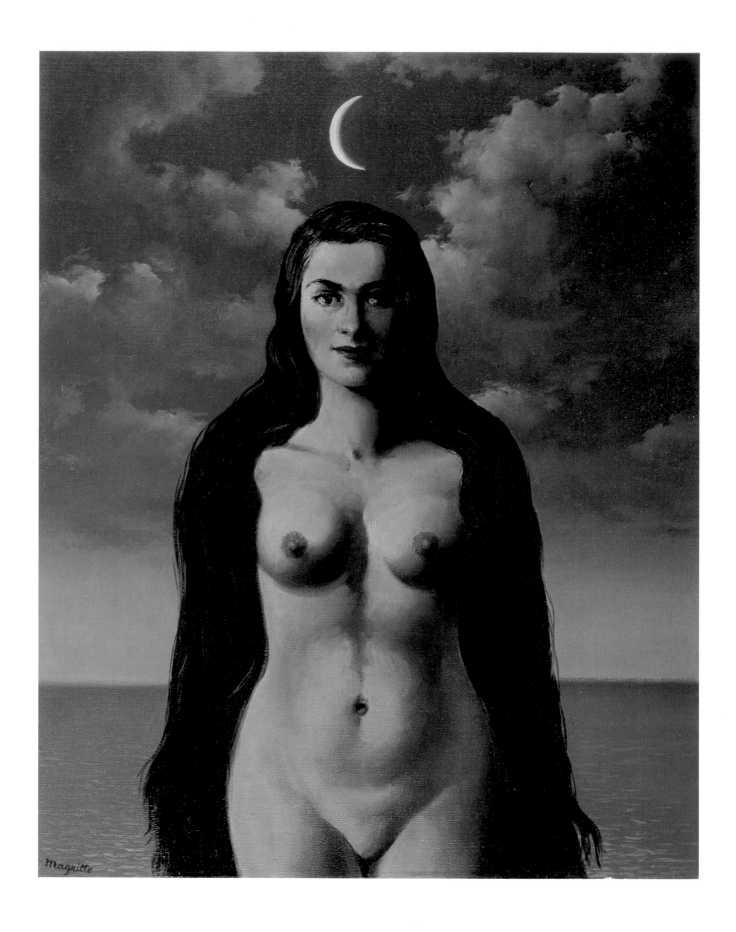

31

*La Robe de Galatée*
Galatea's Robe
1961

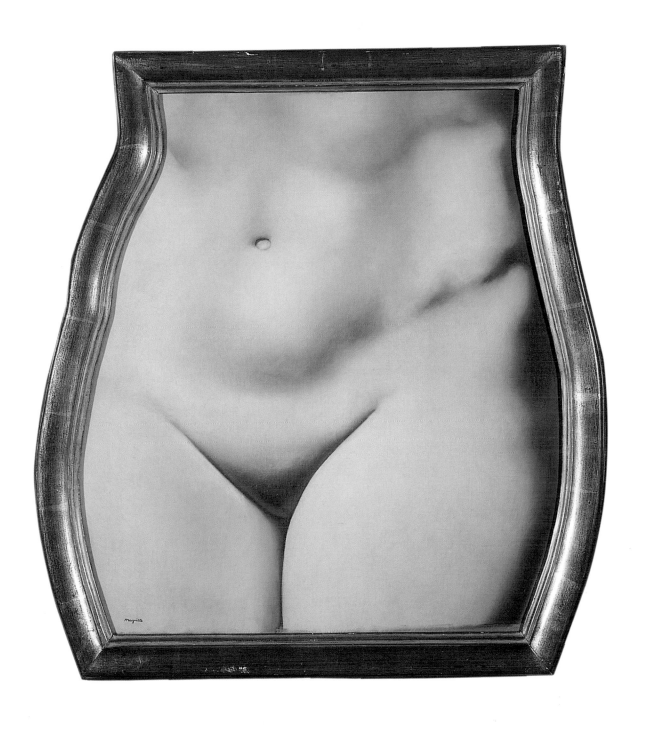

32

*La Représentation*
Representation

1937

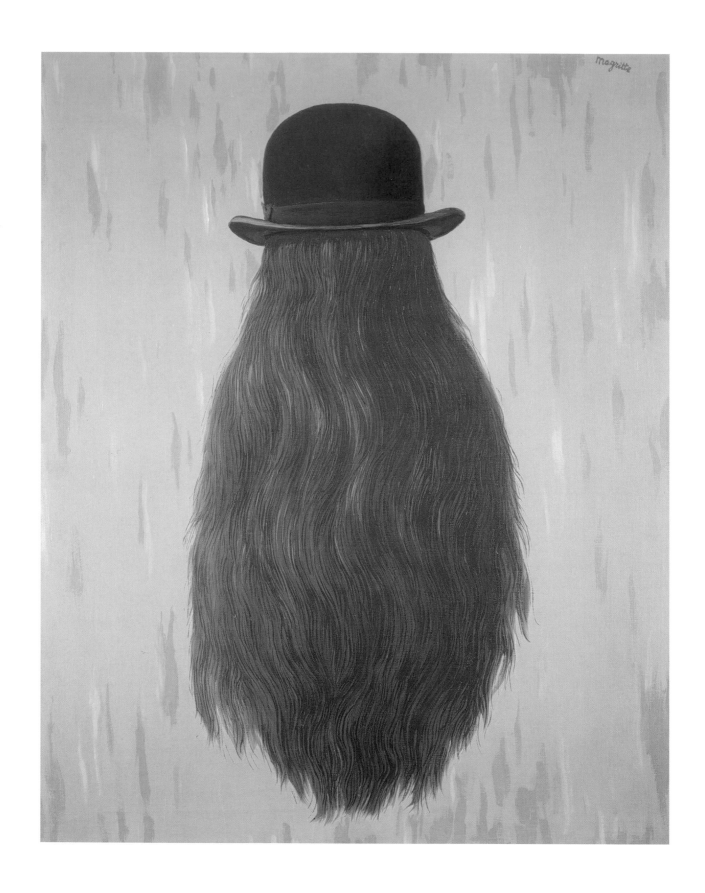

33

*Le Pan de nuit*
The patch of night
1965

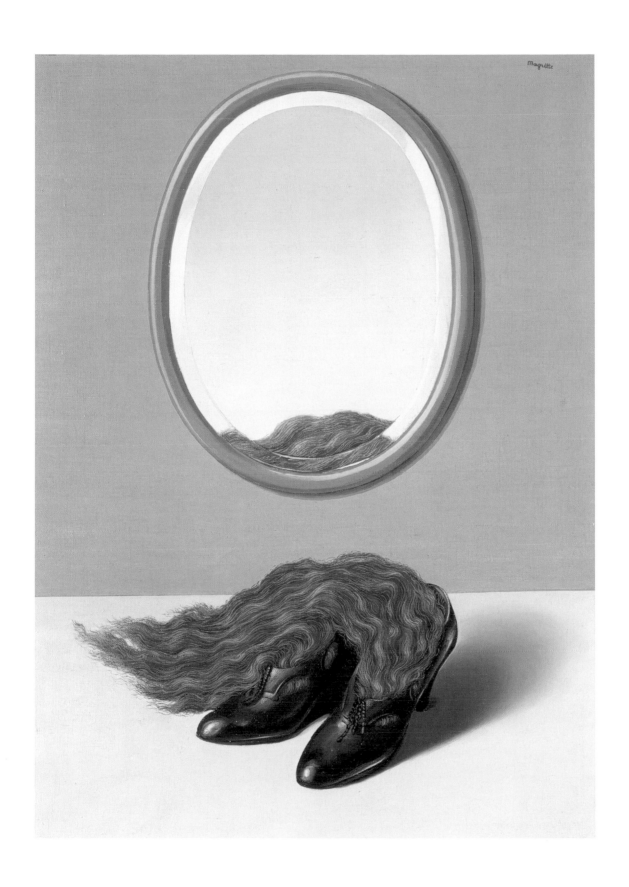

34

*L'Amour désarmé*
Love Disarmed

1935

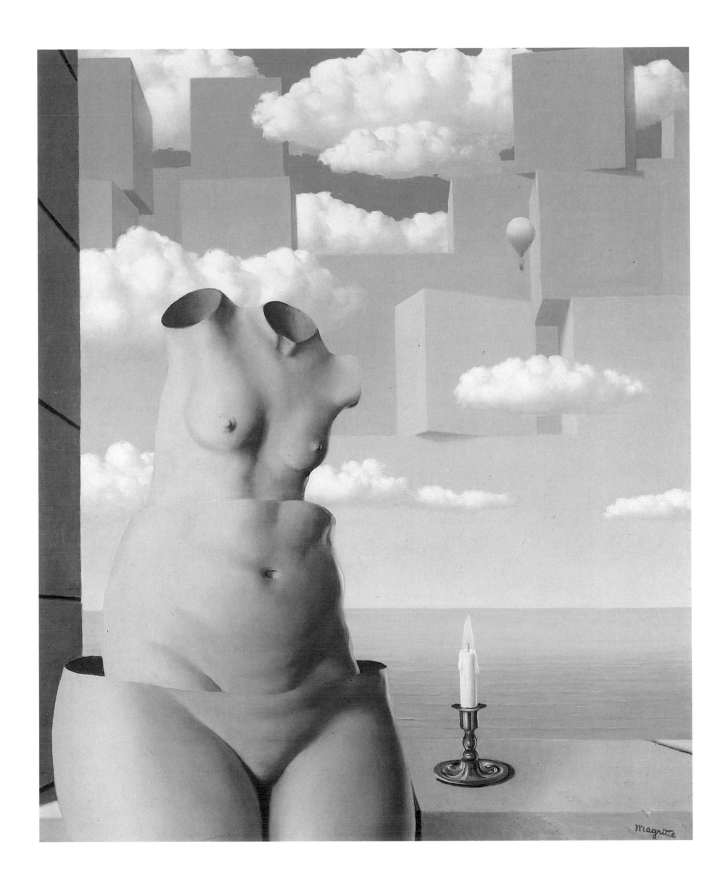

35

*La Folie des grandeurs*
Megalomania
1948 or 1949

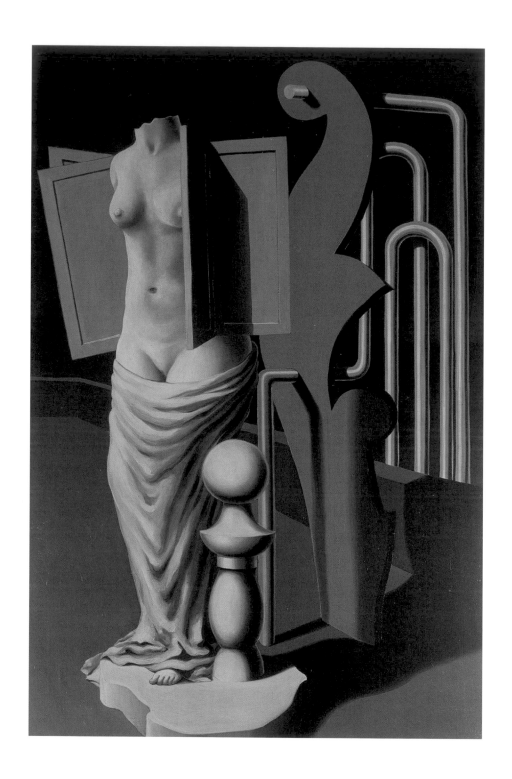

36

*La Statue volante*
The Flying Statue
1932–33

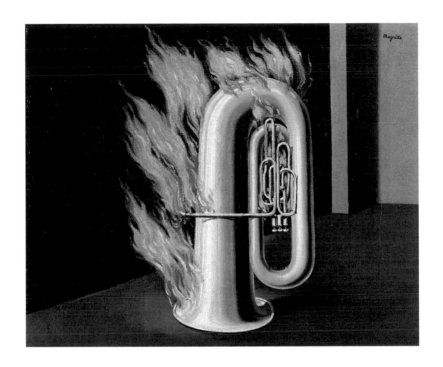

37

*La Découverte du feu*
The Discovery of Fire

1934 or 1935

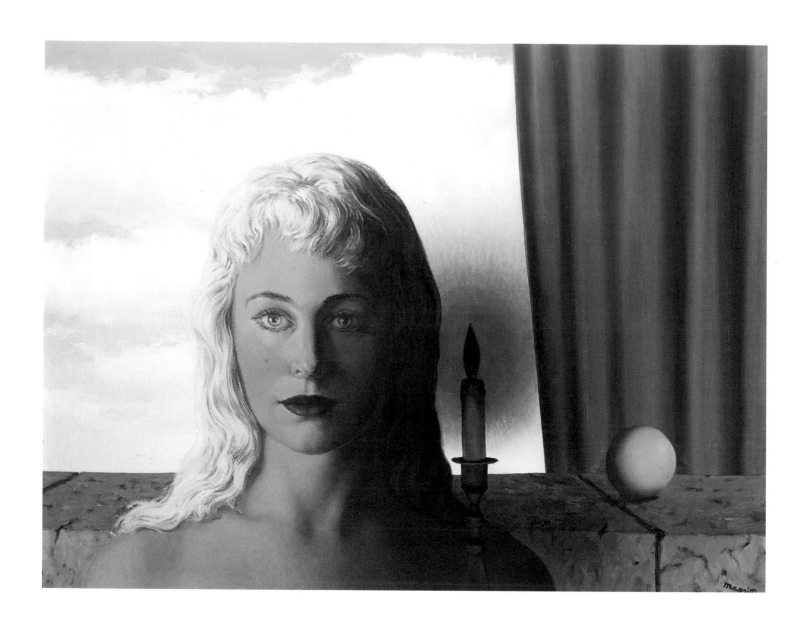

*La Fée ignorante*
The Ignorant Fairy
1956

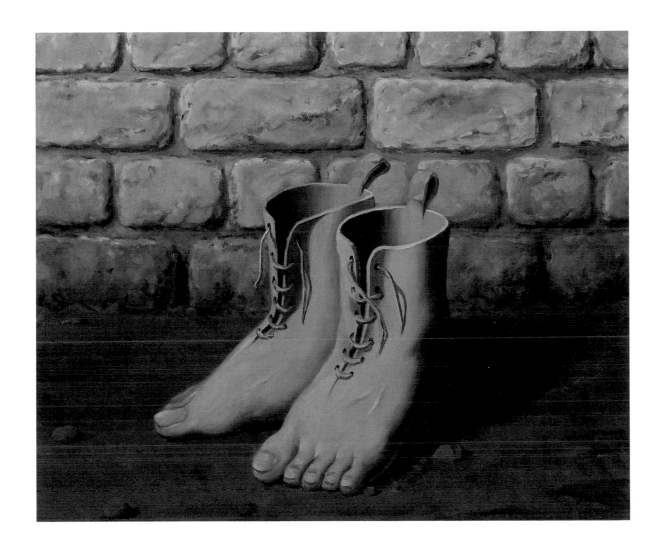

39

*Le Modèle rouge*
The Red Model

1953

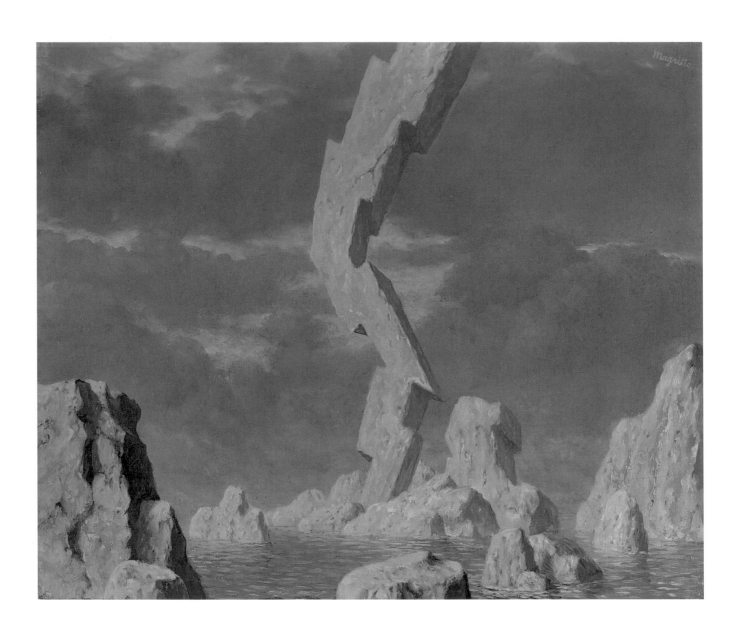

40

*Le Château hanté*
The Haunted Castle
1950

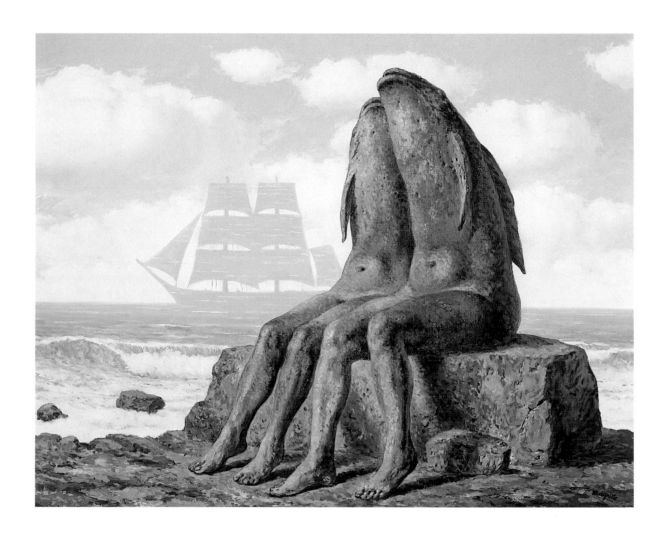

41

*Les Merveilles de la nature*
The Wonders of Nature

1953

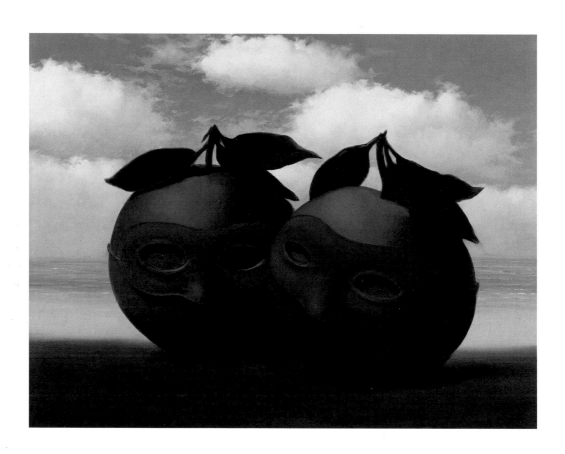

*La Valse hésitation*
The Hesitation Waltz
1950

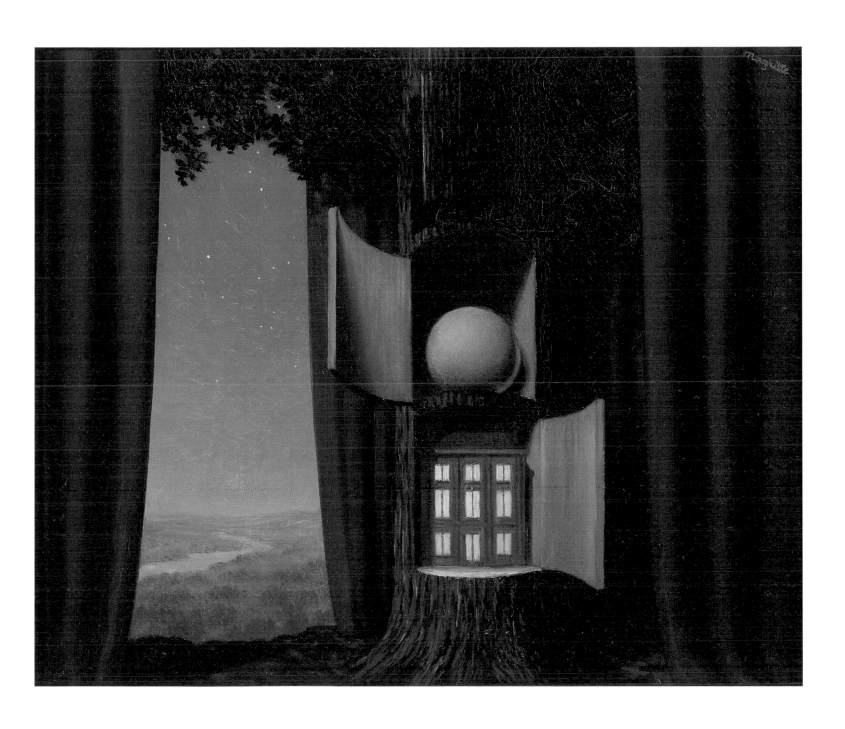

43

*La Voix du sang*
Blood Will Tell

1948

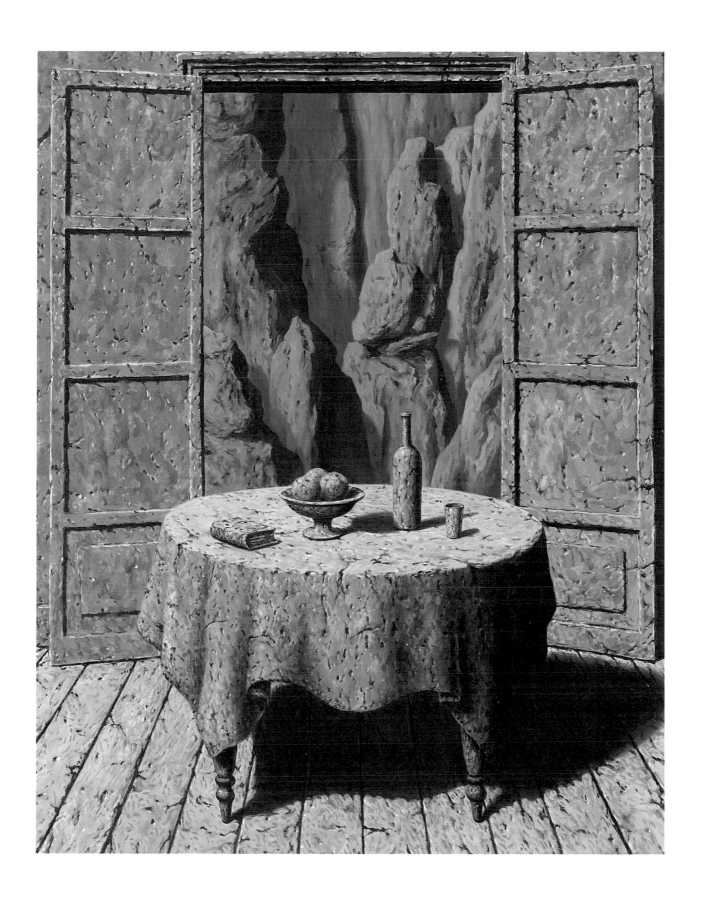

44

*Souvenir de voyage*
Memory of a Journey
1951

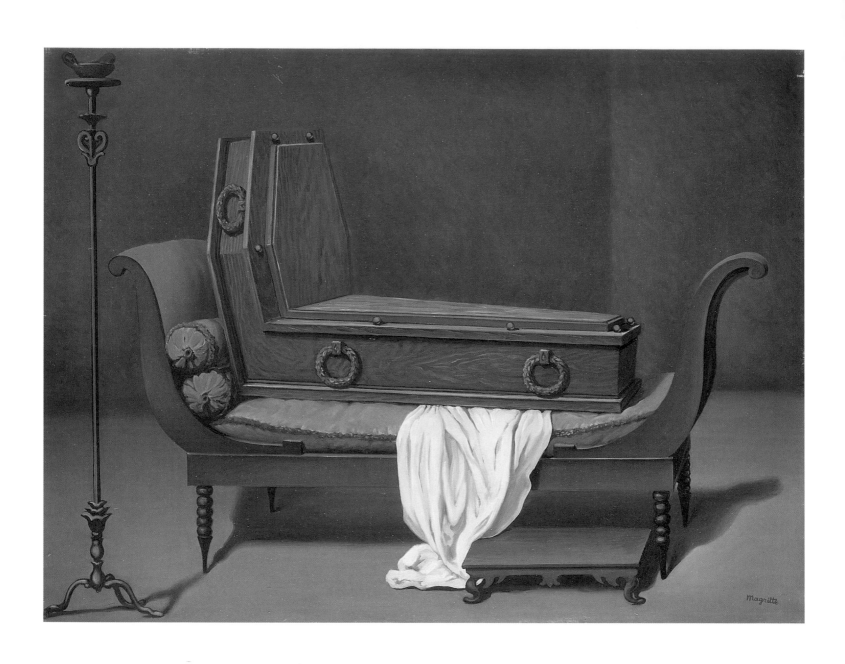

45

*Perspective:* Madame Récamier *de David*
Perspective: David's *Madame Récamier*

1950

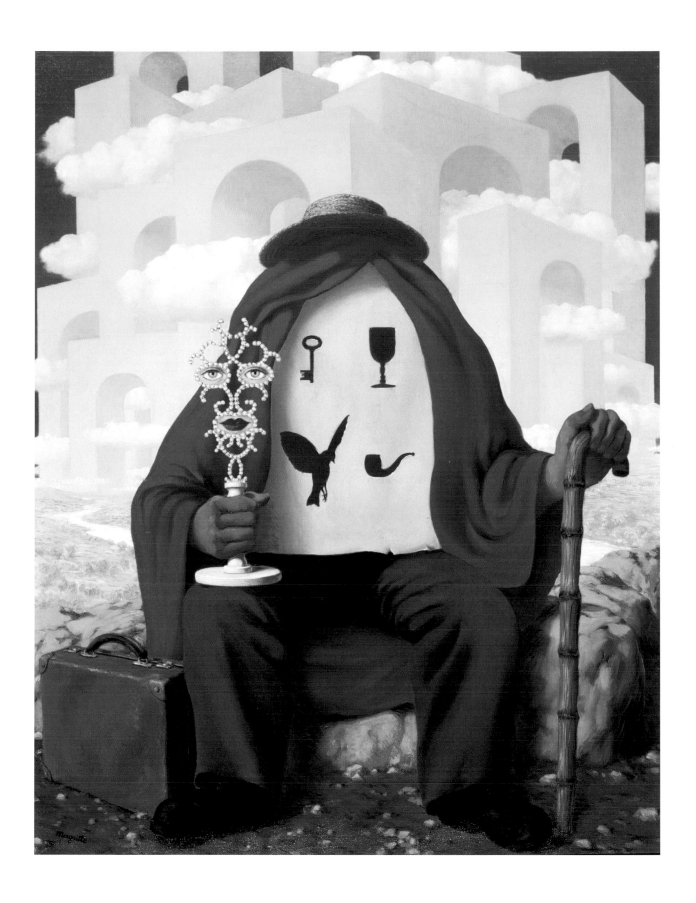

46

*Le Libérateur*
The Liberator

1947

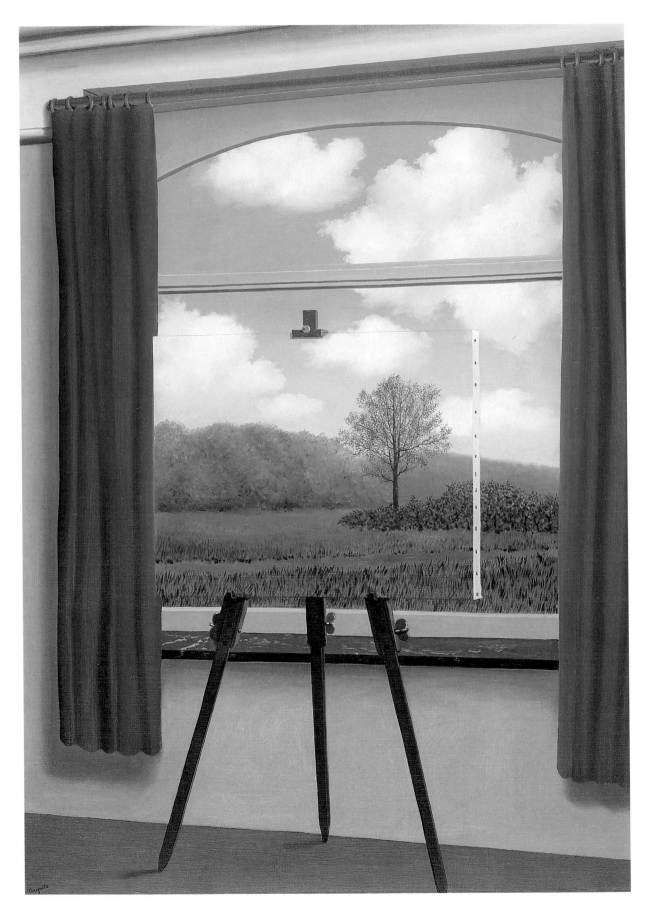

47

*La Condition humaine*
The Human Condition

1933

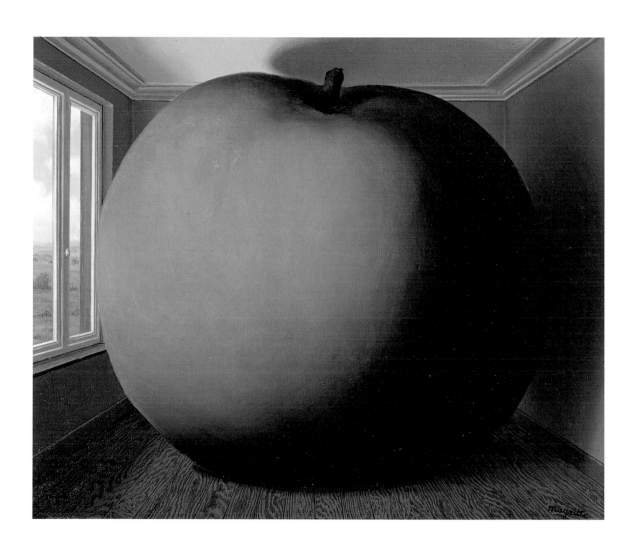

48

*La Chambre d'écoute*
The Listening Room
1952

49
—
*L'Anniversaire*
The Anniversary
1959

50

*La Clef de verre*
The Glass Key

1959

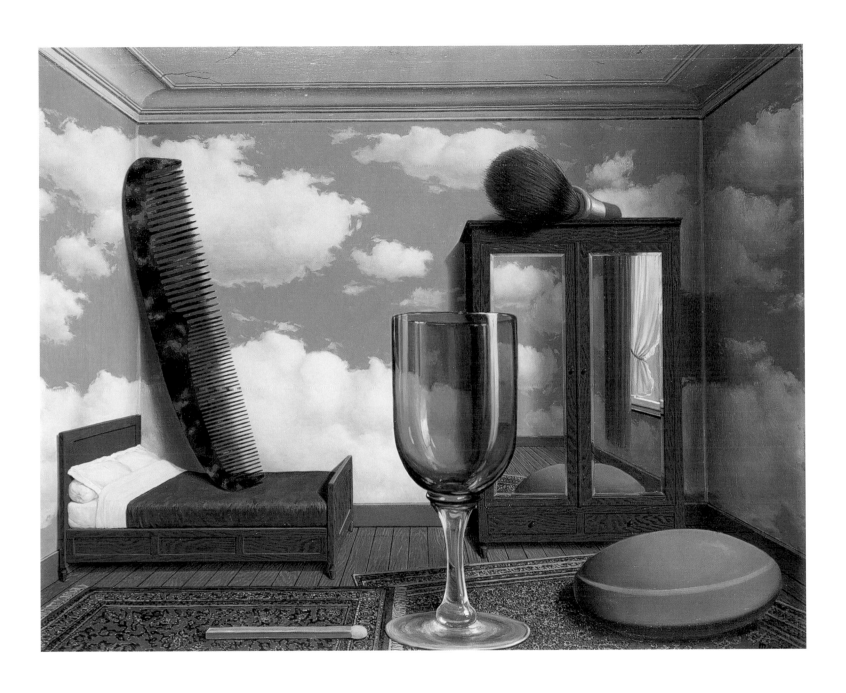

51

*Les Valeurs personnelles*
Personal Values

1952

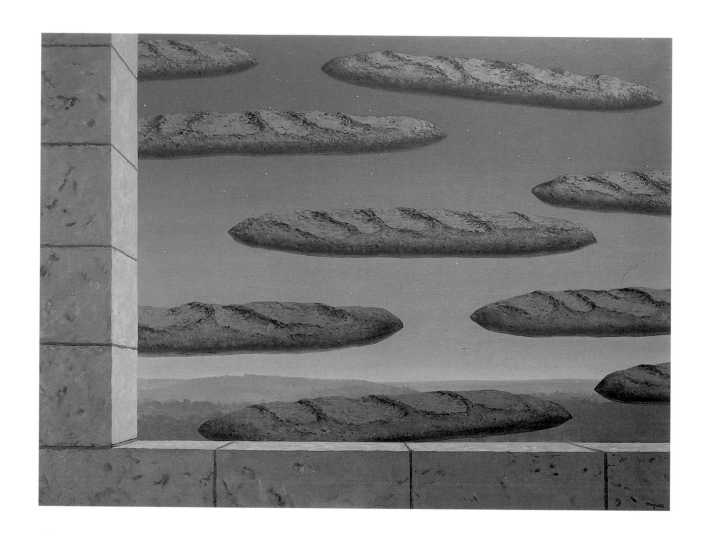

*La Légende dorée*
The Golden Legend
1958

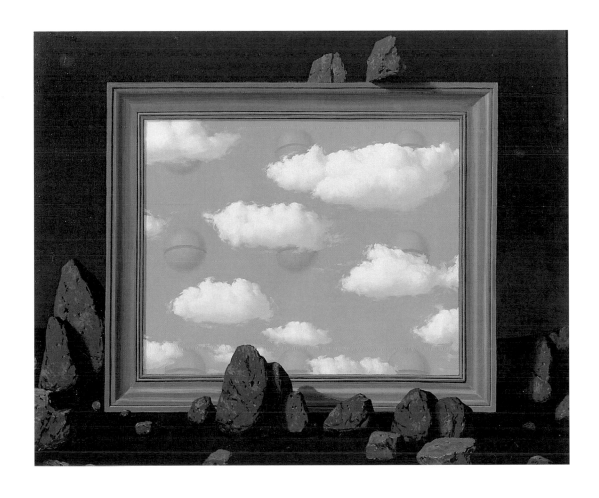

53

*La Grande Marée*
The Spring Tide
1951

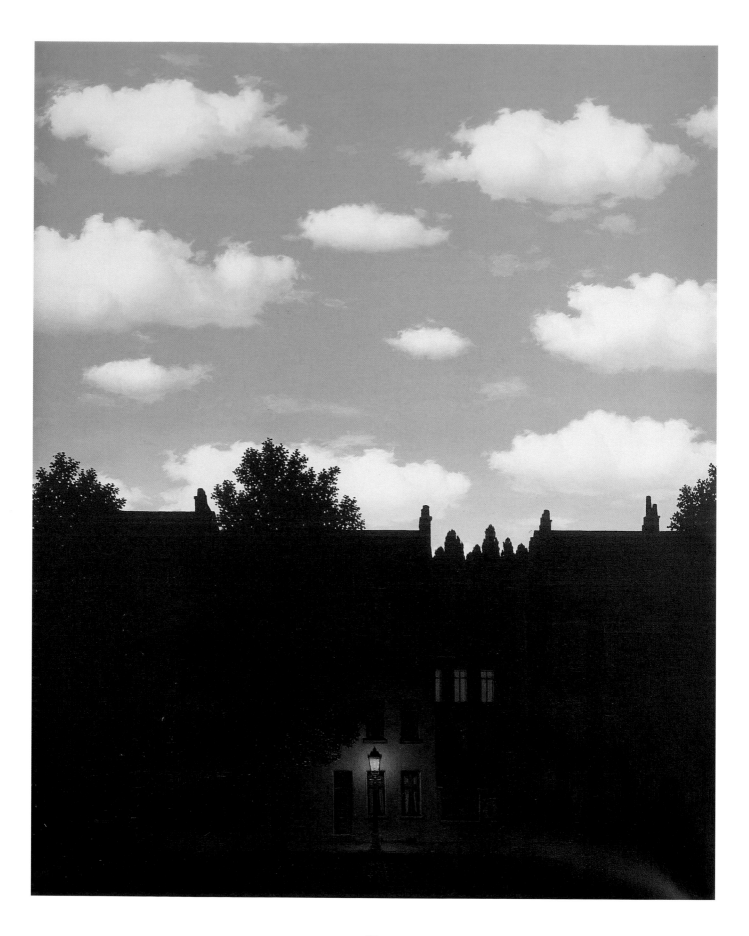

54

*L'Empire des lumières*
The Dominion of Light

1952

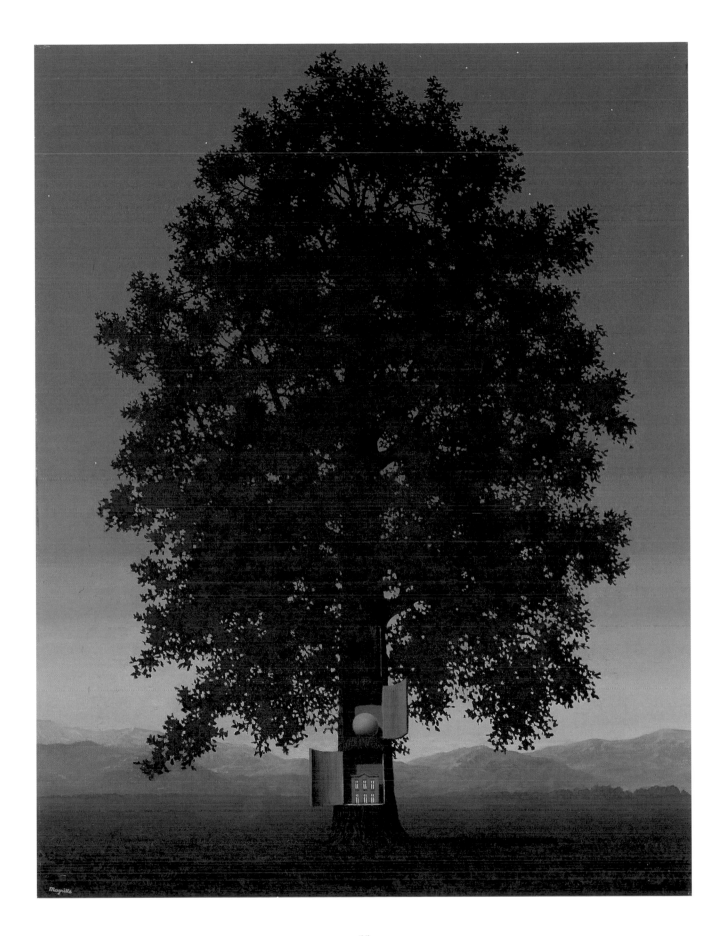

55

*La Voix du sang*
Blood Will Tell

1959

56

*Les Grâces naturelles*
The Natural Graces

ca. 1961

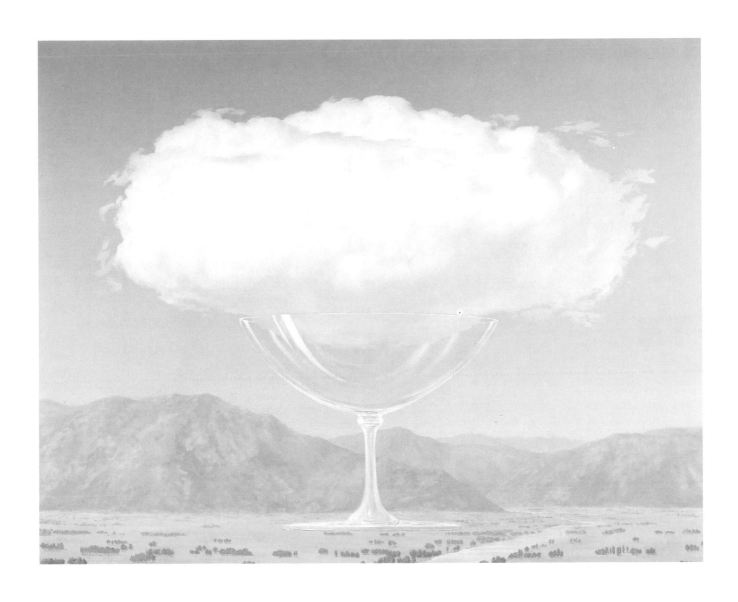

57

*La Corde sensible*
The Heartstring
1960

*Le Territoire*
The Territory
1957

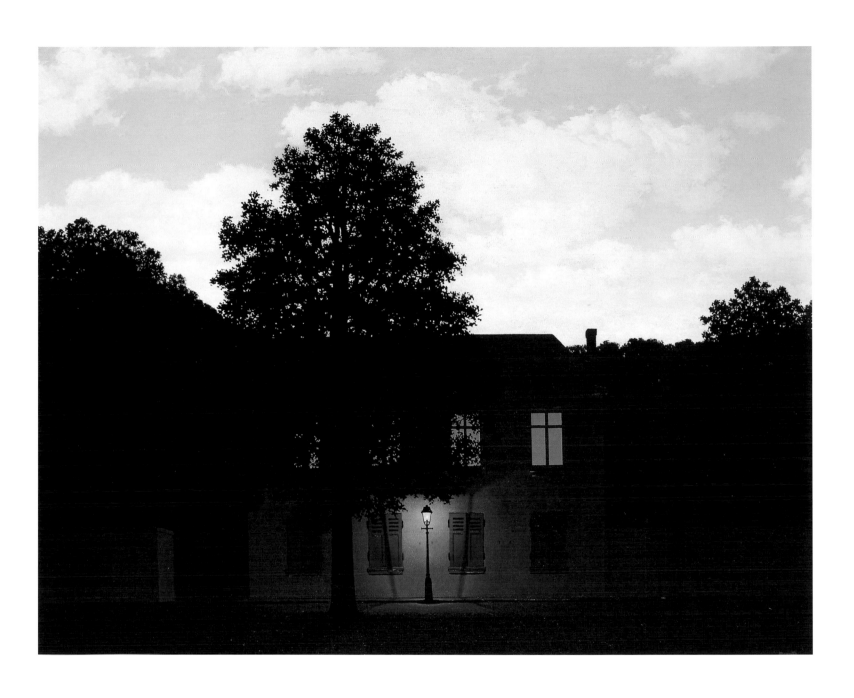

59

*L'Empire des lumières*
The Dominion of Light
1961

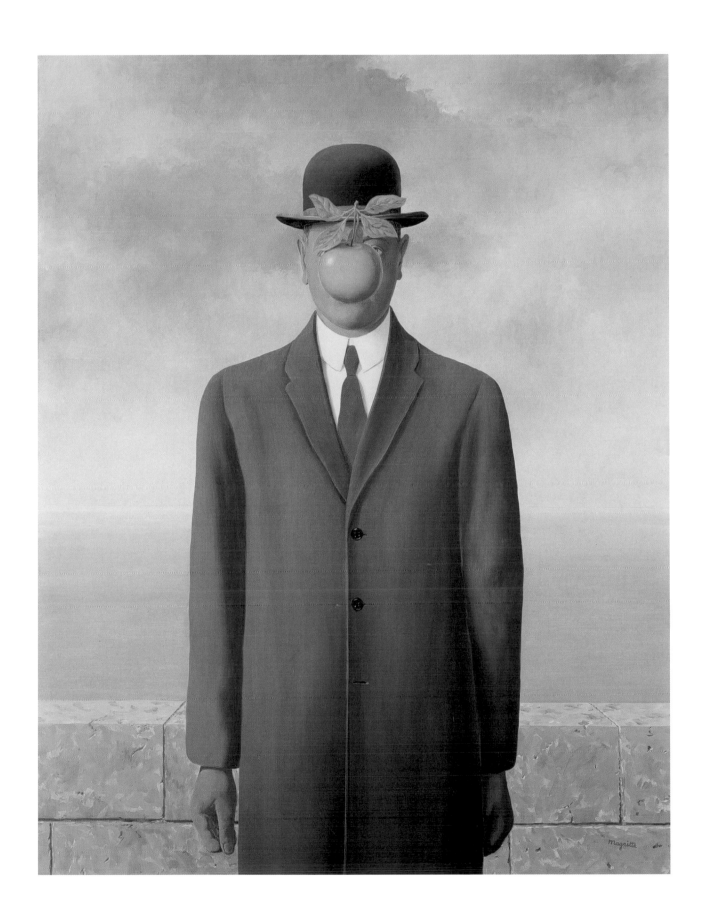

60

—

*Le Fils de l'homme*
The Son of Man
1964

61

*La Bonne Foi*
Good Faith
1964–65

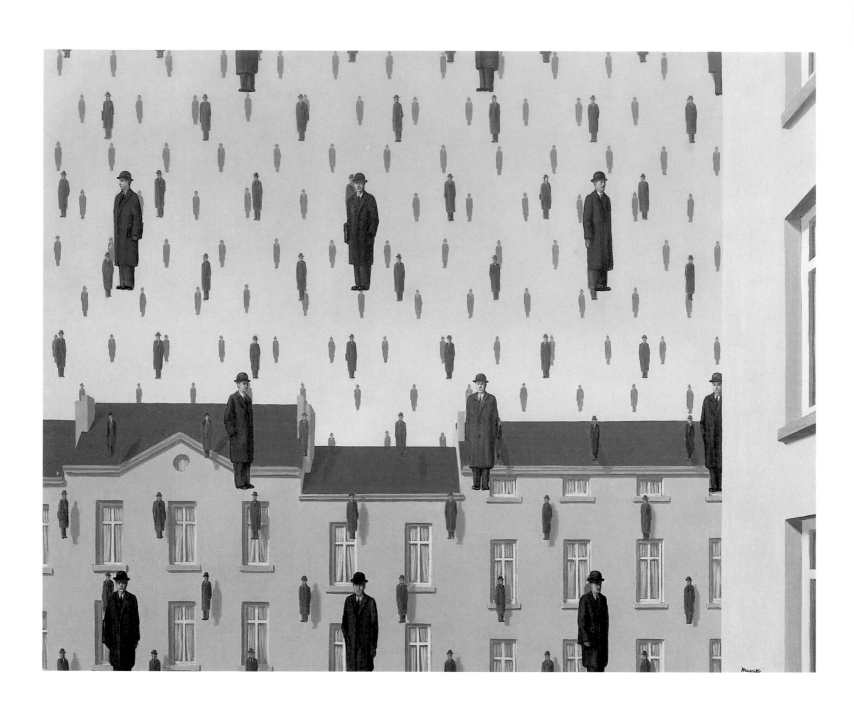

62

*Golconde*
Golconda

1953

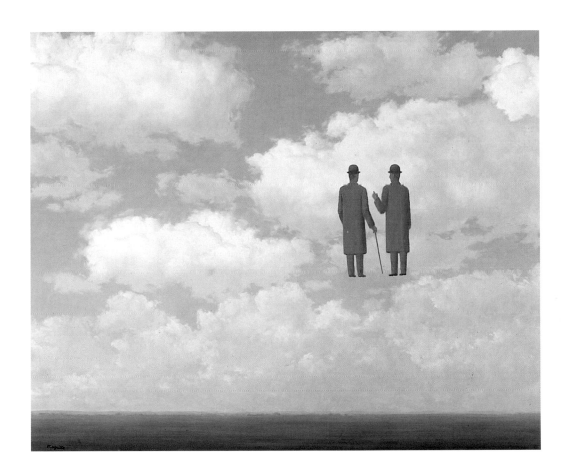

63

*La Reconnaissance infinie*
Reconnaissance without End

1963

# LIST OF PLATES

1

*Paysage* (Landscape), 1927
oil on canvas
39⅜ x 28¾ in. (100 x 73 cm)
Private collection

2

*Le Sang du monde* (The Blood of the World), 1927
oil on canvas
28¾ x 39⅜ in. (73 x 100 cm)
Private collection

3

*Les Épaves de l'ombre* (The Wreckage of the Dark), 1926
oil on canvas
47¼ x 31½ in. (120 x 80 cm)
Collection of the Musée de Grenoble

4

*Le Conquérant* (The Conqueror), 1926
oil on canvas
25⅜ x 29⅝ in. (65 x 75 cm)
Collection of Leslee and David Rogath

5

*La Naissance de l'idole* (The Birth of the Idol), 1926
oil on canvas
47¼ x 31½ in. (120 x 80 cm)
Collection of Louise and Bernard Lamarre

6

*Le Visage du génie* (The Face of Genius), 1926

oil on canvas

29½ x 25⅝ in. (75 x 65 cm)

Collection of the Musée d'Ixelles, Brussels

7

*La Catapulte du désert* (The Desert Catapult), 1926

oil on canvas

29½ x 25⅝ in. (75 x 65 cm)

Private collection, Belgium

8

*Le Supplice de la vestale* (The Torture of the Vestal Virgin), 1927

oil on canvas

37⅜ x 28¾ in. (97.5 x 74.5 cm)

Private collection, courtesy Galerie Christine and Isy Brachot

9

*Les Habitants du fleuve* (The Denizens of the River), 1926

oil on canvas

28¾ x 39⅜ in. (73 x 100 cm)

Private collection

10

*Les Charmes du paysage* (The Delights of Landscape), 1928

oil on canvas

21¼ x 28¾ in. (54 x 73 cm)

Collection of Mr. Roger Nellens

11

*L'Espion* (The Spy), 1928

oil on canvas

21¼ x 28¾ in. (54 x 73 cm)

Courtesy of the Mayor Gallery

12

*L'Homme au journal* (The Man with the Newspaper), 1928

oil on canvas

45⅝ x 31⅞ in. (116 x 81 cm)

Collection of the Tate Gallery, London. Presented by the Friends of the Tate Gallery, 1964

13

*La Lectrice soumise* (The Subjugated Reader), 1928

oil on canvas

36¼ x 28¾ in. (92 x 73 cm)

Courtesy of Galerie Brüsberg, Berlin

14

*L'Histoire centrale* (The Central Story), 1928

oil on canvas

45⅝ x 31⅞ in. (116 x 81 cm)

Collection of Banque Artesia Belgique

15

*Les Six Eléments* (The Six Elements), 1929

oil on canvas

28¾ x 39⅜ in. (73 x 100 cm)

Collection of the Philadelphia Museum of Art,

The Louise and Walter Arensberg Collection

16

*Les Fleurs de l'abîme* (The Flowers of the Abyss), 1928
oil on canvas
21¼ x 28¾ in. (54 x 73 cm)
Private collection, Belgium

17

*Le Palais de rideaux* (The Palace of Curtains), 1935
oil on canvas mounted on board
10⅝ x 16⅛ in. (27 x 41 cm)
Collection of Pierre and Mickey Alechinsky

18

*Le Drapeau noir* (The Black Flag), 1937
oil on canvas
21¼ in. x 28¾ in. (54 cm x 73 cm)
Collection of the Scottish National Gallery of Modern Art, Edinburgh

19

*Le Prince des objets* (The Prince of Objects), 1927
oil on canvas with collaged canvas
19⅝ x 25⅝ in. (50 x 65 cm)
Private collection, courtesy Galerie Vedovi

20

*L'Espoir rapide* (Swift Hope), 1927
oil on canvas
19⅝ x 25⅝ in. (50 x 65 cm)
Collection of the Hamburger Kunsthalle, Hamburg

21

*La Trahison des images* (The Treachery of Images), 1929
oil on canvas
23⅝ x 31⅞ (60 x 81 cm)
Collection of the Los Angeles County Museum of Art, purchased with funds
provided by the Mr. and Mrs. William Preston Harrison Collection

22

*La Voix de l'absolu* (The Voice of the Absolute), 1955
oil on canvas
15¾ x 19⅝ in. (40 x 50 cm)
Private collection, Brussels

23

*La Table, l'océan, et le fruit* (Table, Ocean, and Fruit), 1927
oil on canvas
19⅝ x 25⅝ in. (50 x 65 cm)
Private collection, Brussels

24

*Le Miroir vivant* (The Living Mirror), 1928
oil on canvas
21¼ x 28¾ in. (54 x 73 cm)
Private collection

25

*La Preuve mystérieuse* (The Mysterious Proof), 1927
oil on canvas
19⅝ x 25⅝ in. (50 x 65 cm)
Collection of Arakawa and Madeline Gins

26

*Le Sens propre* (The Literal meaning), 1929
oil on canvas
28¾ x 21¼ in. (73 x 54 cm)
The Menil Collection, Houston

27

*Le Sens propre* (The Literal Meaning), 1929
oil on canvas
29½ x 21¼ in. (73 x 54 cm)
Collection of the Robert Rauschenberg Foundation

28

*Baigneuse du clair au sombre* (Bather between Light and Darkness), 1936
oil on canvas
35 x 45⅝ in. (89 x 116 cm)
Private collection, Chicago

29

*L'Evidence éternelle* (The Eternally Obvious), 1930
oil on five canvases
8⅝ x 4¾ in.; 7½ x 9⅜ in.; 10⅝ x 7½ in ; 8⅝ x 6¼ in.;
8⅝ x 4¾ in. (22 x 12 cm; 19 x 24 cm; 27 x 19 cm; 22 x 16 cm; 22 x 12 cm)
The Menil Collection, Houston

30

*Le Viol* (The Rape), 1934
oil on canvas
28¾ x 21¼ in. (73 x 54 cm)
The Menil Collection, Houston

31

*La Robe de Galatée* (Galatea's Robe) 1961
oil on canvas
25⅝ x 19⅝ in. (65 x 50 cm)
Private collection

32

*La Représentation* (Representation), 1937
oil on canvas
19⅛ x 17⅜ in. (48.5 x 44 cm)
Collection of the Scottish National Gallery of Modern Art, Edinburgh

33

*Le Pan de nuit* (The Patch of Night), 1965
oil on canvas
21⅝ x 18⅛ in. (55 x 46 cm)
Collection of Elkon Gallery, Inc.

34

*L'Amour désarmé* (Love Disarmed), 1935
oil on canvas
28⅜ x 21¼ in. (72 x 54 cm)
Private collection

35

*La Folie des grandeurs* (Megalomania), 1948 or 1949
oil on canvas
39⅜ x 31½ in. (100 x 80 cm)
Collection of the Hirshhorn Museum and Sculpture Garden,
Smithsonian Institution, Gift of Joseph H. Hirshhorn, 1966

36

*La Statue volante* (The Flying Statue), 1932–33
oil on canvas
47¼ x 31½ in. (120 x 80 cm)
Private collection

37

*La Découverte du feu* (The Discovery of Fire), 1934 or 1935
oil on canvas
13 x 16⅛ in. (33 x 41 cm)
Collection of Leslee and David Rogath

38

*La Fée ignorante* (The Ignorant Fairy), 1956
oil on canvas
19⅝ x 25⅝ in. (50 x 65 cm)
Private collection

39

*Le Modèle rouge* (The Red Model), 1953
oil on canvas
15 x 18⅛ in. (38 x 46 cm)
Collection of Fortis Bank, Brussels

40

*Le Château hanté* (The Haunted Castle), 1950
oil on canvas
15 x 18⅛ in. (38 x 46 cm)
Collection of the Sprengel Museum, Hannover

41

*Les Merveilles de la nature* (The Wonders of Nature), 1953
oil on canvas
31½ x 39⅜ in. (80 x 100 cm)
Collection of the Museum of Contemporary Art, Chicago,
Gift of Joseph and Jory Shapiro

42

*La Valse hésitation* (The Hesitation Waltz), 1950
oil on canvas
13⅞ x 18 in. (35 x 46 cm)
Collection of Leslee and David Rogath

43

*La Voix du sang* (Blood Will Tell), 1948
oil on canvas
19⅝ x 23⅝ in. (50 x 60 cm)
Private collection

44

*Souvenir de voyage* (Memory of a Journey), 1951
oil on canvas
31½ x 25⅝ in. (80 x 65 cm)
Private collection

45

*Perspective:* Madame Récamier *de David* (Perspective: David's *Madame Récamier*), 1950
oil on canvas
23⅝ x 31½ in. (60 x 80 cm)
Private collection, courtesy Guggenheim Asher Associates, Inc.

46

*Le Libérateur* (The Liberator), 1947
oil on canvas
39⅜ x 31½ in. (100 x 80 cm)
Collection of the Los Angeles County Museum of Art, Gift of William Copley

47

*La Condition humaine* (The Human Condition), 1933
oil on canvas
39 x 31½ in. (100 x 80 cm)
Collection of the National Gallery of Art, Washington, D.C.,
Gift of the Collectors' Comittee

48

*La Chambre d'écoute* (The Listening Room), 1952
oil on canvas
17¾ x 21⅝ in. (45 x 55 cm)
The Menil Collection, Houston

49

*L'Anniversaire* (The Anniversary), 1959
oil on canvas
35 x 45⅝ in. (89 x 116 cm)
Collection of the Art Gallery of Ontario,
Purchase, Corporations' Subscription Endowment, 1971

50

*La Clef de verre* (The Glass Key), 1959
oil on canvas
51⅛ x 63¾ in. (130 x 162 cm)
The Menil Collection, Houston

51

*Les Valeurs personnelles* (Personal Values), 1952
oil on canvas
31½ x 39⅜ in. (80 x 100 cm)
Collection of the San Francisco Museum of Modern Art,
Purchased through a gift of Phyllis Wattis

52

*La Légende dorée* (The Golden Legend), 1958
oil on canvas
38⅛ x 51⅛ in. (97 x 130 cm)
Collection of Leslee and David Rogath

53

*La Grande Marée* (The Spring Tide), 1951
oil on canvas
25⅝ x 31½ in. (65 x 80 cm)
Private collection, Brussels

54

*L'Empire des lumières* (The Dominion of Light), 1952
oil on canvas
39⅜ x 31½ in. (100 x 80 cm)
Collection of Lois and Georges de Menil

55

*La Voix du sang* (Blood Will Tell), 1959

oil on canvas

45⅝ x 35 in. (116 x 89 cm)

Collection of the Museum moderner Kunst, Stiftung Ludwig, Vienna

56

*Les Grâces naturelles* (The Natural Graces), ca. 1961

oil on canvas

31⅞ x 39⅜ in. (81 x 100 cm)

Private collection

57

*La Corde sensible* (The Heartstring), 1960

oil on canvas

44⅞ x 57½ in. (114 x 146 cm)

Private collection, Belgium

58

*Le Territoire* (The Territory), 1957

oil on canvas

29½ x 47¼ in. (75 x 120 cm)

Collection of Madame Maria Do-Céu Cupertino de Miranda

59

*L'Empire des lumières* (The Dominion of Light), 1961

oil on canvas

44⅞ x 57½ in. (114 x 146 cm)

Private collection

60

*Le Fils de l'homme* (The Son of Man), 1964

oil on canvas

45⅝ x 35 in. (116 x 89 cm)

Private collection

61

*La Bonne Foi* (Good Faith), 1964–65

oil on canvas

16⅛ x 13 in. (41 x 33 cm)

Private collection, Brussels

62

*Golconde* (Golconda), 1953

oil on canvas

31¾ x 39⅝ in. (80.7 x 100.6 cm)

The Menil Collection, Houston

63

*La Reconnaissance infinie* (Reconnaissance without End), 1963

oil on canvas

32 x 39½ in. (81 x 100 cm)

Collection of Leslee and David Rogath

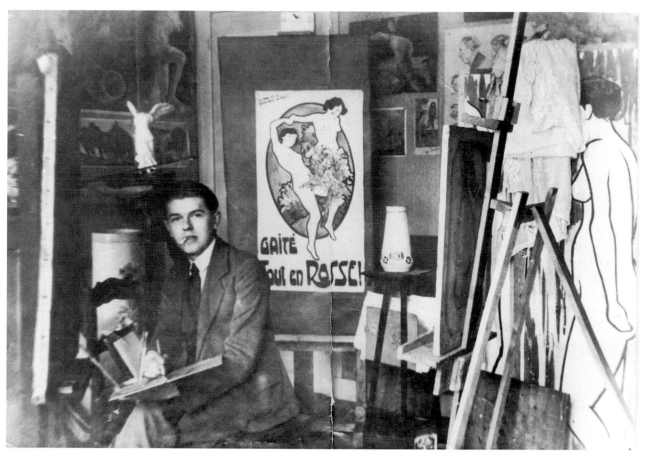

*Magritte in his studio in Brussels, ca. 1920.*

## BIOGRAPHY

1898 René-François-Ghislain Magritte is born on November 21 in Lessines in the Hainaut province in Belgium, the eldest of three sons. His mother, Régina Bertinchamps, works as a milliner until her marriage. His father, Léopold Magritte, is a merchant tailor and businessman.

1910 Magritte begins to paint and to draw in a weekly art class. He attends the local middle school.

1912 His mother commits suicide by throwing herself into the Sambre River. When her body is discovered, she is naked and her nightdress is covering her face. It is said that Magritte recalls this event through the representation of veiled faces in his work.

1915 In his first works Magritte adopts an Impressionist style and technique.

1916 Magritte shows two drawings and two paintings at an exhibition in Châtelet. He begins his studies at the Académie des Beaux-Arts in Brussels where he also takes a literature course with the writer Georges Eekhoud.

1918 Magritte's first commercial poster, an advertisement for Pot au Feu Derbaix, is published.

1919 Magritte contributes drawings to the first issue of the review *Au volant*. His poster designs are displayed in a special section at the inaugural exhibition at the Centre d'Art in Brussels.

1920 Pierre Flouquet and Magritte exhibit paintings and posters at the Centre d'Art. By chance, he runs into Georgette Berger, who works with her older sister Léontine at the Coopérative Artistique in Brussels. He meets E. L. T. Mesens, a young musician, who shares his enthusiasm for the avant-garde. Magritte and Mesens write to the Italian futurists. Later on, they become

interested in Dada, under the influence of Erik Satie and Tristan Tzara, whom Mesens meets in 1921. For the first time his paintings are shown at an international exhibition in Geneva.

1921 Magritte is hired as a designer by the Peters-Lacroix wallpaper factory in Haren.

1922 He marries Georgette Berger in Brussels. Magritte has the furniture for their apartment made according to his own designs. Together with Victor Servranckx, he writes "L'Art pur. Défense de l'esthétique," a text influenced by the Purist theories of Le Corbusier and Amédée Ozenfant and the Cubist theories of Pierre Reverdy. His work at this time is influenced by Robert Delaunay, Fernand Léger, and Purism.

1923 Magritte participates in several exhibitions in Belgium and abroad. He is deeply impressed by the reproduction of Giorgio de Chirico's painting *The Song of Love*, which he probably discovered in the review *Les Feuilles libres*. It is not until 1925, however, that he begins to paint in a style that reflects this discovery. He meets Camille Goemans, one of the first Brussels writers involved in the Surrealist movement.

1924 He leaves the Peters-Lacroix wallpaper factory and attempts to earn a living "doing idiotic work: posters and publicity designs," as he writes in his autobiographical notes. His first commercial work is for Norine, the most important couture house in Brussels. Magritte receives a grant of five hundred francs from the Belgian government. However, this sum does not enable him to devote himself solely to painting and he produces relatively little. Thanks to E. L. T. Mesens, he is invited to contribute to Francis Picabia's review *391* and becomes actively involved in the Dada movement. Together with Mesens, Goemans, and the writer Marcel Lecomte, he issues a prospectus for the Dada review *Période*. Magritte and Mesens continue this project while Goemans and Lecomte join Paul Nougé in publishing *Correspondance*, which will capture the attention of the Paris Surrealists. Nougé, who will become Magritte's friend and mentor, henceforth dominates Belgian Surrealism. Magritte sells his first painting, a portrait of the singer Evelyne Brélia.

1925 Magritte collaborates with Mesens on the Dada review *Oesophage*, whose only issue appears in March. "Norine Blues," a song composed by his brother Paul Magritte with lyrics by René and Georgette Magritte (under the pseudonym René Georges), is performed at a fashion show organized by Norine in Ostend. Magritte designs the cover of the music score. He paints his first Surrealist works, his major influences being Giorgio de Chirico and Max Ernst. The latter's influence leads him to make papiers collés.

1926 Magritte signs a four-year contract with P.-G. Van Hecke and the new Galerie Le Centaure in Brussels. During this period, he produces 280 oil paintings, almost one quarter of his entire painted œuvre. He contributes to Mesens's review *Marie*. The second of three issues includes a drawing of the character "Fantômas," who will reappear in several works. At the same time he designs advertisements.

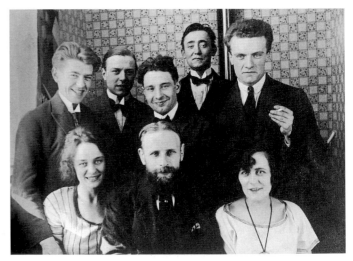

*At the Magrittes' home in Brussels, 1922. First row (from left): Georgette Magritte, Pierre Broodcoorens, and Henriette Flouquet. Second row: René Magritte, E. L. T. Mesens, Victor Servranckx, Pierre Flouquet, and Pierre Bourgeois.*

A Belgian Surrealist group takes shape with Magritte, Mesens, Nougé, Goemans, and the composer André Souris forming the nucleus.

1927 Magritte's first one-man exhibition is held at the Galerie Le Centaure in Brussels. The catalogue contains sixty-one works—forty-nine oils and twelve papiers collés—and includes texts by Van Hecke and Nougé. The reaction on the part of the press is largely hostile. He meets Louis Scutenaire, with whom he will have a very close friendship for forty years. During the summer, he makes papiers collés to illustrate commercial catalogues. The Magrittes move to Perreux-sur-Marne in the suburbs of Paris. They stay there for three years and partake in the activities of the Paris Surrealist group. In Paris, they frequently see Goemans, Paul Eluard, André Breton, Joan Miró, Hans Arp, and later, Salvador Dalí.

1928 A one-man show is held at the Brussels Galerie L'Epoque, which is run by Mesens. Magritte paints over one hundred pictures, making this one of the most prolific years of his career. He con-

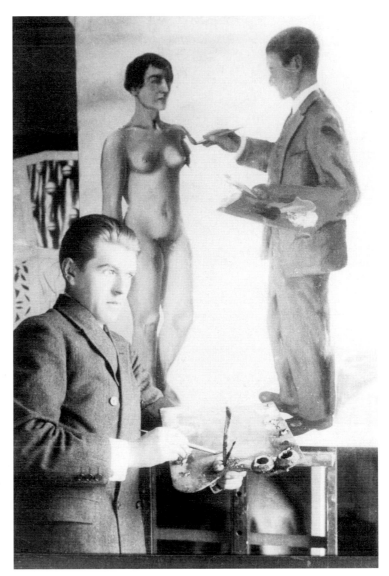

*Magritte with the painting* Tentative de l'impossible *(Attempting the Impossible) in his studio in Perreux-sur-Marne, 1928.*

tributes to the review *Distances*, founded by Nougé and Goemans. Although Magritte is not mentioned in André Breton's book *Le Surréalisme et la peinture*, and does not participate in the "Exposition surréaliste" at the Galerie au Sacre du Printemps in Paris, he is eventually accepted into the Paris Surrealist group. Breton acquires several of Magritte's paintings. In August, his father dies in Brussels.

1929 In the spring, Magritte meets Dalí, who is in Paris for the shooting of the film *Un Chien andalou*. The Magrittes spend their vacation with Dalí at Cadaqués in Spain in the company of, among others, Gala and Paul Eluard. The Galerie Goemans opens in Paris with an exhibition of works by Hans Arp, Salvador Dalí, Yves Tanguy, and Magritte. Magritte contributes to the last issue of *La Révolution surréaliste* with the text "Les Mots et les images." His relationship with Breton becomes strained.

1930 Magritte participates in the group exhibition of collages organized by Goemans and the lyric poet Louis Aragon at the Galerie Goemans in Paris. Aragon's text "La Peinture au défi" serves as the preface to the catalogue. As Camille Goemans closes his gallery for financial and personal reasons, Magritte finds himself without a dealer. In order to survive, he must sell some of his books. Fortunately, Mesens buys eleven recent works from him. The Magrittes leave Paris and

return to Brussels. In need of financial resources, he resumes his commercial art and sets up Studio Dongo with his brother Paul.

1931  Magritte's work is shown in the exhibition *L'Art vivant en Belgique 1910–1930* at the Galerie Georges Giroux in Brussels. This is the first exhibition organized by L'Art vivant, a society recently created to promote contemporary art. Magritte exhibits for the first time at the Palais des Beaux-Arts in Brussels.

1932  Magritte signs the tract "La Poésie transfigurée" in which the Belgian Surrealists demonstrate their attitude towards the letter of protest "L'Affaire Aragon" by the Parisian Surrealists. Magritte cooperates with Nougé on two short films.

1933  Breton invites Magritte to contribute to the review *Le Surréalisme au service de la révolution*, marking his reconciliation with the Paris Surrealists. He will also be invited to participate in the Surrealist group showing at the Salon des Surindépendants. One-man exhibition at the Palais des Beaux-Arts in Brussels.

1934  Magritte is represented at the large international exhibition *Le Nu dans l'art vivant* organized by La Société Auxiliaire des Expositions and *L'Art vivant* at the Palais des Beaux-Arts. He draws *Le Viol* (The Rape) for the cover of André Breton's *Qu'est-ce que le surréalisme?*, published by Henriquez in Brussels. He participates in the exhibition *Minotaure* at the Palais des Beaux-Arts.

1935  Magritte's production increases considerably with the prospect of, among other things, a one-man exhibition in New York. He signs the tract "Du Temps que les surréalistes avaient raison," published in Paris, which marks the split between the Surrealists and the Communist Party. Although Magritte still supports Communist causes, it seems that he does not actually join the party until 1945. The third issue of the *Bulletin international du surréalisme*, featuring a cover gouache by Magritte, is published in Brussels. Paul Eluard's poem "René Magritte" is published for the first time in *Cahiers d'art* in Paris. Magritte participates in the Surrealist exhibition organized by Mesens at La Louvière.

1936  Magritte's first one-man exhibition in the United States is held at the Julien Levy Gallery in New York. He signs the tract "Le Domestique zélé" announcing the expulsion of André Souris from the Belgian Surrealist group. A one-man exhibition is held at the Palais des Beaux-Arts in Brussels. He participates in "Exposition surréaliste d'objets" organized at the Galerie Charles Ratton in Paris by, among others, Breton. He shows eight oils and six works on paper at the first major international Surrealist exhibition in London. His work is also shown in *Fantastic Art, Dada, Surrealism*, an exhibition organized at the Museum of Modern Art in New York by Alfred H. Barr, Jr.

1937  Magritte spends five weeks at the London home of Edward James working on three large commissions: *Le Modèle rouge* (The Red Model), *La Jeunesse illustrée* (Youth Illustrated) and *Au Seuil de la liberté* (On the Threshold of Freedom). During his stay, he gives a talk on his work at the London Gallery. He meets Marcel Mariën. Their friendship will last until 1954. He participates in the exhibition *Trois peintres surréalistes: René Magritte, Man Ray, Yves Tanguy* at the Palais des Beaux-Arts in Brussels. The catalogue contains an introduction by Scutenaire, a reprint of a poem by Eluard and an epigram on each artist by Breton.

1938   Second one-man exhibition at the Julien Levy Gallery in New York. Magritte participates in the *Exposition internationale du surréalisme* at the Galerie des Beaux-Arts in Paris. This exhibition is organized by Breton and Eluard in conjunction with Marcel Duchamp. Mesens and Roland Penrose take over the London Gallery and open with an exhibition by Magritte. A large part of the first issue of the *London Bulletin* is also devoted to him.

1939   One-man exhibition at the Palais des Beaux-Arts in Brussels.

1940   First issue of the new Surrealist review *L'Invention collective*. Magritte is one of the principal contributors to the review. He leaves Belgium following the German occupation and spends three months in Carcassonne with Irène and Louis Scutenaire.

1941   One-man exhibition at the Galerie Dietrich in Brussels.

1942   Magritte compiles the documentation for a monograph by Scutenaire that will be published in 1947 under the title *René Magritte*. Robert Cocriamont makes the first film on Magritte entitled *Rencontre de René Magritte*, based on a scenario by Nougé.

1943   During the next four years, Magritte's style changes radically as he adopts an Impressionist palette and technique. This period is commonly referred to as his "Renoir period." He explains in a letter to Breton of June 24, 1946: "There is a misunderstanding concerning the accusation that I am imitating Renoir. I painted pictures in the style of Renoir, Ingres, Rubens, etc. but, rather than imitating Renoir's particular technique, I employed the technique of Impressionism—that of Renoir, Seurat, and the others." This style of painting will coexist with Magritte's usual style until 1947. Paul Nougé's book *René Magritte ou les images défendues* is published. The manuscript dates from 1933.

1944   The one-man exhibition at the Galerie Dietrich in Brussels shows Magritte's "Impressionist" work for the first time. Marc Eemans, an artist linked with Surrealism in its early days but now allied with the Nazis in their fight against "degenerate art," unfavorably reviews the exhibition in the press.

1945   Magritte makes pen-and-ink drawings to illustrate Le Comte de Lautréamont's poem "Les Chants de Maldoror." He makes similar drawings for a volume of poems by Eluard, *Les Nécessités de la vie et les conséquences des rêves précédés d'exemples*. Magritte's membership in the Belgian Communist Party is announced. A large Surrealist exhibition at the Galerie des Editions La Boétie in Brussels showcases Belgian artists. Magritte's leading role in Belgian Surrealism is reflected in his large contribution to the show, both in terms of organization and in the number of works that he enters.

1946   Magritte, Nougé, and Mariën publish anonymous subversive and scatological tracts: *L'Imbécile* (The Imbecile), *L'Emmerdeur* (The Pain in the Arse) and *L'Enculeur* (The Buggerer). Most of them are confiscated by the postal service. He reestablishes contact with Breton and Picabia during his first postwar visit to Paris. In the text "Le Surréalisme en plein soleil," he outlines a more optimistic concept for future Surrealism, the key words being "pleasure" and "light," and at another one-man exhibition at the Galerie Dietrich in Brussels Nougé defends Magritte's "sunlit Surrealism" in the introduction to the catalogue.

1947  Magritte's first one-man exhibition orga-
nized by the American dealer Alexandre
Iolas is held at the Hugo Gallery in New
York. On the occasion of the international
exhibition of Surrealism organized at the
Galerie Maeght in Paris, Breton openly con-
demns Magritte's concept of "sunlit
Surrealism." Magritte is excommunicated.
Louis Scutenaire's monograph, completed in
1942, is published in Brussels. Magritte par-
ticipates in an international exhibition orga-
nized by L'Amicale des Artistes
Communistes de Belgique.

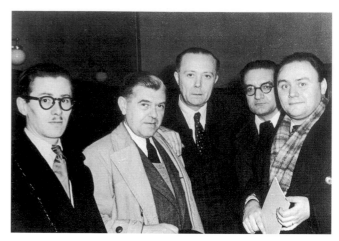

*Marcel Mariën, René Magritte, Louis Scutenaire, Paul Nougé, and
Noël Arnaud, 1947.*

1948  An exhibition at the Galerie Dietrich in Brussels reflects Magritte's abandonment of his
"Impressionist" style and another one-man exhibition is organized at Iolas's Hugo Gallery in
New York. Magritte's first one-man exhibition in Paris is held at the Galerie du Faubourg. He
exhibits recent paintings and gouaches executed in a completely new manner—his "vache"
style ("cow" style), an allusion to the term "fauve" (which in Magritte's interpretation means
"deer" as well as "wild"). In his text for the catalogue, "Les Pieds dans le plat," Scutenaire
employs a litany of slang, dialect, puns, etc.

1950  Dominique and Jean de Menil purchase a work by Magritte from Iolas to donate to the
Museum of Modern Art in New York.

1951  An exhibition of some forty works opens at Iolas's gallery in New York. In Brussels, two
galleries exhibit recent works.

1952  The first postwar retrospective of Magritte's work is organized at the Casino Communal in
Knokke. Magritte establishes *La Carte d'après nature*, a review that will appear irregularly
until April 1956, generally in the shape of a postcard. He breaks off his friendship with
Nougé.

1953  Magritte's first exhibition in Italy is held at the Galleria dell'Obelisco in Rome, where Giorgio
de Chirico is among its visitors. Gustave Nellens accepts Magritte's preliminary gouache
sketches and commissions a mural for the Salle de Lustre in the Casino Communal at Knokke.
For this project, the artist makes eight oil paintings to scale which are then translated onto the
walls by a team of painters. Magritte supervises the work and entitles it *Le Domaine enchanté*
(The Enchanted Domain).

1954  *Word vs Image*, an exhibition of Magritte's word paintings, is held at the Sidney Janis Gallery
in New York. Thanks to this initiative by Mesens, American critics and the general public
alike discover one of the important aspects of Magritte's œuvre. In the course of the next two
decades, Robert Rauschenberg, Jasper Johns, Roy Lichtenstein, and Andy Warhol will acquire
word pictures by Magritte. The first major retrospective of Magritte's work is held at the
Palais des Beaux-Arts in Brussels. He writes two texts for the catalogue. A retrospective of
twenty-four works by the artist is presented at the Belgian pavilion of the Venice Biennale,
whose main theme is Surrealism.

1955 Exhibition at the Galerie Cahiers d'Art in Paris.

1956 Magritte is commissioned to paint a mural for the Salle des Congrès in the new Palais des Beaux-Arts at Charleroi. In the autumn, he buys a movie camera and makes short films— Surrealist "home movies"—in which he films himself, Georgette, Louis Scutenaire, Irène Hamoir, Paul Colinet, and other friends. Most of these films are in black and white, the later ones are in color. Magritte signs a contract which gives Iolas exclusive rights to his entire production of the following year.

1957 Opening of his first one-man exhibition at Iolas's New York gallery for four years. He meets Harry Torczyner, who becomes his friend, legal adviser, patron, and the author of a monograph on him.

1959 Two exhibitions are organized simultaneously in New York by Iolas: one at his gallery and the other at the Bodley Gallery. Duchamp writes a short introduction for the invitation: "Des Magritte en cher, en hausse, en noir et en c uleurs [sic]." (The literal translation of this pun is "Works by Magritte, expensive and increasing in price, in black and white and in color"; however, "en cher, en hausse" is a play on "en chair et en os," meaning "in the flesh," and "en c uleurs" is a play on "enculeur," meaning "buggerer.") His production declines considerably. Luc de Heusch directs the film *Magritte ou La Leçon des choses. Poèmes 1923–1958*, by E. L. T. Mesens, is published in Paris with drawings by Magritte.

1960 Suzi Gablik, a young artist and critic, spends eight months with the Magrittes. She prepares a study on the painter that will be published in London in 1970. From December 1960 to March 1961, a retrospective is held in Dallas and in Houston.

1961 The first issue of *Rhétorique* is published. This review is the result of a close collaboration between André Bosmans and Magritte and includes texts by Scutenaire, Colinet, Achille Chavée, and Geert van Bruaene. Magritte paints a mural for the new Palais des Congrès in Brussels. In the autumn, two one-man exhibitions open in London: the first is organized by E. L. T. Mesens at the Grosvenor Gallery and the other is held at the Obelisk Gallery. Breton's contribution to the latter's exhibition catalogue is considered to be the most substantial text that he wrote on Magritte.

1962 Iolas organizes an exhibition at his New York gallery. A large retrospective opens in Knokke. Marcel Mariën issues a satirical prospectus entitled "Grande Baisse" (Great Bargain Sale) in which he mocks Magritte's lucrative habit of making several copies of the same paintings in order to satisfy public demand. The retrospective *The Vision of René Magritte* opens at the Walker Art Center in Minneapolis.

1963 Most of these years' production is commissioned by Belgian collectors. Iolas continues to actively promote Magritte's work in Europe and the United States. A large retrospective exhibition is held at the Arkansas Art Center in Little Rock.

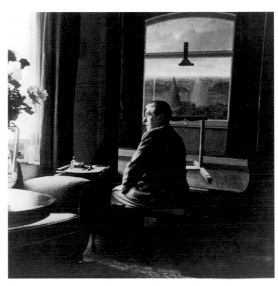

*Magritte with the painting* Les Promenades d'Euclide *(Where Euclid Walked), 1955.*

1965 Magritte is forced to interrupt his work for health reasons. The Museum of Modern Art in New York dedicates a large retrospective to him that features works from European and American collections. The following year, the exhibition travels to Waltham, Chicago, Pasadena, and Berkeley. Magritte and Georgette go to New York for the opening of the MoMA exhibition and spend some time in Houston as well. Patrick Waldberg's monograph is published.

1967 A one-man exhibition is held at Iolas's Paris gallery. In the same month, according to Iolas, Magritte comes up with the idea to have sculptures made based on his work. He chooses eight subjects from his paintings and sets to work on the project. During a trip to Italy with Georgette and the Scutenaires, he visits the Gibiesse foundry in Verona where the sculptures are being made. He corrects and signs the waxes. The bronzes will be cast after his death. A large retrospective opens at the Museum Boijmans Van Beuningen in Rotterdam and travels to the Moderna Museet in Stockholm. René Magritte dies of pancreatic cancer at his home on August 15.

*Based on a biography by Carine Fol.*

*René Magritte photographed by Duane Michals, 1965.*